C000225448

LOST COUNTRY HOUSES F

NORTH AND EAST
YORKSHIRE

IAN GREAVES

AMBERLEY

For David Neave and Edward Waterson, founders of Yorkshire lost house studies. With thanks.

This edition first published 2024

Amberley Publishing
The Hill, Stroud
Gloucestershire GL5 4EP

www.amberley-books.com

British Library Cataloguing in Publication Data.
A catalogue record for this book is available from the British Library.

ISBN 978 1 3981 1624 5 (print)
ISBN 978 1 3981 1625 2 (ebook)

Typesetting by SJmagic DESIGN SERVICES, India.
Printed in Great Britain.

Introduction

This is the first volume in a series covering the lost houses of what might broadly be called the North East (Northumberland, County Durham and Yorkshire). It offers information on a wide range of houses and the families that built and occupied them. The North and East Ridings offer a diverse range of landscapes and, consequently, a wide range of buildings; some the ancient seats of families locally dominant for centuries, others the product of new money, usually industrial in the North Riding where the wealthy of Leeds and Bradford moved away from the sources of their money and associated with shipping and commerce in the East.

Yorkshire as a whole has lost more country houses than any other county. However, this is largely the result of its size. In truth, there has only been a handful of lost houses of national architectural significance. Not covered in this book, for obvious reasons, are the many houses and estates that remain, through good management or luck, in the hands of those that built them or have owned them for centuries. Equally, the loss of the social structures based around great houses has brought correspondingly significant change in the social strictures of rural communities. This is true of both North and East Yorkshire, but in the latter there have, in addition, been very significant losses amongst the houses built by merchants, shipowners and shipbuilders during the heyday of Hull as one of Britain's greatest ports. A similar pattern is seen in York and Middlesbrough where, in the case of the latter, vast fortunes were made as a result of a relatively brief boom in iron and steel production. In the cases of these towns and cities, I have had to exercise a degree of subjectivity in deciding exactly what constitutes a country house.

The traditional country estates were most commonly lost to death duties, falling rent rolls or, on occasion, failure to provide an heir. These were not the only reasons. To take merely a handful of examples, Kirkleatham, a very significant loss, was simply too large to survive and was swallowed up by industrial Teesside; its stables, of great importance, survive, boarded up and unused. Studley Royal, of no great distinction but the heart of a great estate, was destroyed by fire; Sedbury was replaced by a serviceable but undistinguished modern house; and Rounton Grange, Webb's masterpiece, was lost after being turned down by the National Trust and it is impossible to discount the likelihood that snobbery played a large part in this wrongheaded decision. Like Studley Royal, some of these houses disappeared long before the plight of country houses was brought to general attention. It is impossible not to feel that had a few survived just a few more years they might have found alternative uses as schools, institutions or in shared ownership. Some might have improved the landscape of our post-industrial towns and cities and the lives of their inhabitants – Marton Hall in Middlesbrough is a good example.

The histories I have included are as accurate and complete as I can make them; however, I am well aware that there will be mistakes or omissions, and for these I can only apologise. I believe I have included all the significant lost houses, although I am conscious of the fact that there are likely to be some smaller houses worthy of inclusion that I have missed. I would, of course, be delighted to receive corrections, further information or especially illustrations where I have been unable to locate them. I have taken the opportunity to include brief stories associated with many of the houses, and I have a soft spot for an occasional ghost story, so have included some of these too. I would be happy to assist, where I can, with requests for information regarding individual houses. Please contact me at ian@doctors.org.uk.

I am most grateful to my family for putting up with this project over several years, and I would also like to take this opportunity to thank all the staff of the local libraries, history departments and archives for their kindness in locating material for me. I would like to express my gratitude to all those listed in the illustration credits given at the end of the book, but I would like to pay particular tribute to Matthew Beckett and his Lost Heritage website.

My greatest debt is to the 'fathers' (I hope they won't mind the term) of North East lost country house studies, David Neave and Edward Waterson, for their kindness and generosity. This book is, with their permission, dedicated to them.

North Riding

Acomb Priory, York
The site did not have any prior religious associations and what became Acomb Priory was originally known as Plantation Hall, changing its name in the late nineteenth century. It was demolished after 1932 and replaced by a printing works and housing.

Askrigg Old Hall, Askrigg
Askrigg Old Hall stood in the centre of the small Dales town made famous as the television setting for James Herriot's *All Creatures Great and Small*. It was built in 1678 by William Thornton who placed the inscription 'Every house is builded [*sic*] by some man; but he that built all things is God' over the door.

 The design was effectively semi-detached. It was symmetrical with matching bays rising through four floors on either side and twinned centrally placed front doors. There were also two doors at second-floor level which were connected by a balcony between the windows. The hall passed from the Thorntons to the Lightfoots. Askrigg Old Hall burnt down in 1935.

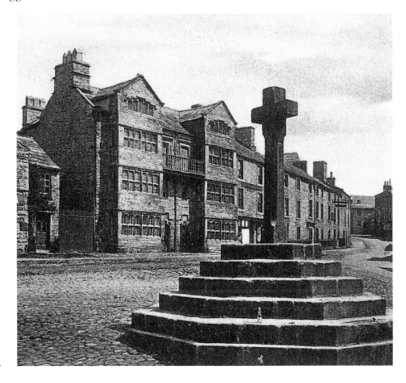

Askrigg Old Hall.

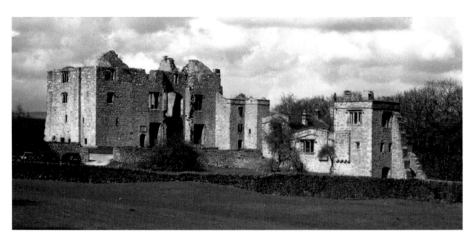

Barden Tower.

Barden Tower, Barden in Wharfedale

Barden was originally a seat of the Norman family of De Romille, then of the Cliffords. After the Battle of Wakefield during the Wars of the Roses, 'Butcher', 'Bloody' or 'Blackfaced' Clifford (depending on your point of view) found 'Young Rutland', heir to the House of York, in Wakefield and murdered him. Clifford was killed at Towton in 1461 and following his death Yorkists sought his son, 'Young Clifford'. For thirty years, Clifford remained disguised as a shepherd. Following the Battle of Bosworth and the end of the conflict, the 'Shepherd Lord' was brought back to Skipton. Restored as the 10th Lord Clifford, he was unable to settle at Skipton, and returned to Barden where he remodelled and extended the tower. Clifford Sr led a troop of Dalesmen to victory at the Battle of Flodden. Halberds used at that battle were passed down to descendants of the combatants and it is said could still be found in some farmhouses in the area in the mid-twentieth century.

Barden was restored by Lady Anne Clifford, who added the chapel in 1658–59. Lady Anne added a large inscription, stating: 'The Ladie Anne Clifford, Countesse Dowager of Pembroke, Dorset and Montgomerie, Baronesse Clifford, Westmorland [restored the tower] after itt had layne ruinous ever since about 1589 when her mother then ley in itt and was great with child with her...'

As late as 1774 the tower was intact. After the countess' death most of the roof was taken off and the tower passed to the Burlington family, and from them to the Dukes of Devonshire, who still own it as part of their Bolton Abbey estate. Part of the tower was occupied until as late as 1900 when the chapel was still used for services. Extensive ruins remain. The farm at Barden Tower was leased from the Bolton Abbey estate by the Lister family from 1659 until the 1970s when it became a tea room.

Beechill Manor House, Knaresborough

The ancient manor house of Beechill in Knaresborough was demolished in the late nineteenth century. From the twelfth century Beechill was a church estate, and the manor was frequently occupied by Knaresborough clergy. In the late seventeenth century the lease of Beechill was granted by the Prebendary of Knaresbough to the Slingsbys of Scriven.

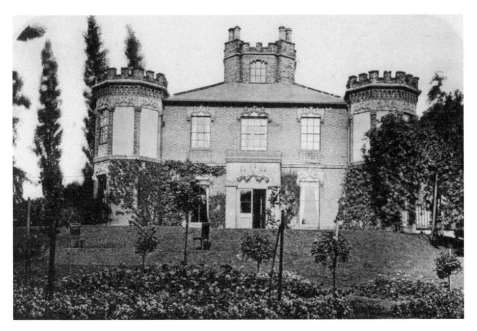

Belle Vue House.

Belle Vue House, York
Belle Vue was probably built by William Plows after he bought the land in 1833. The house was not large but appeared bigger as a consequence of large octagonal towers on each corner and a central tower with a viewing platform on its roof. The details were Gothic, with the windows having ogee heads. Plows sold the house in 1852 and in 1879 it became a nursing home. In 1935 everything except the ground floor shell was demolished. The site was completely cleared in 1985.

Carlton Hall, Aldbrough St John
The Carlton estate was bought by Samuel Mouton Barrett around the turn of the eighteenth century and the house was rebuilt shortly afterwards. Barratt sold the house to the Duke of Northumberland at neighbouring Stanwick, and it remained the home of his agent until the death of Eleanor, widow of the 4th Duke, in 1911. The main block was built of ashlar with a projecting porch, arched windows on the ground floor and rectangular above and with strip pilasters as decoration. There was a lower wing to the side. During the First World War Carlton was used to house German prisoners of war. It was demolished in 1919.

Claxton Hall, York
Probably eighteenth century in origin, Claxton Hall was demolished after a fire in 1981. An army hiring from 1924, Claxton was later a military hospital, and from 1947 to its sale in the year of the fire it was residence of the GOC Northern Command. The house had earlier been a private asylum and during the late nineteenth century was the seat of Frederick, second son of Sir James Walker, Baronet of Sand Hutton Hall.

Clervaux Castle, Croft-on-Tees

Clervaux Castle was designed by Ignatius Bonomi, assisted by John Loughborough Pearson, for William Chaytor and built between 1839 and 1844. The name Clervaux was chosen to mark the Elizabethan connection between the Chaytor and Clervaux families. The Clervauxs came to England when Sir Hammon Clervaux accompanied William the Conqueror, holding land at Croft from the early thirteenth century until their heiress, Elizabeth Clervaux, married Christopher Chaytor.

The exterior of Clervaux was severe but on the whole not unconvincing, with irregularly placed square machicolated towers and a porte-cochere like a medieval keep. The main rooms were based on illustrations from Nash's *Mansions of England in Olden Times* and included some genuinely old reused decorative features. Stables and a clock tower were added in 1844–47.

After Chaytor's death in 1847, Clervaux was occupied by his daughters, including Harriet who died in the 1890s. The castle was left to Sir William Chaytor of Croft Old Hall, who died in 1896. After a time as the residence of one George May, Clervaux was the home of Alfred Chaytor, a grandson of the builder. On Alfred's death in the 1930s the castle stood empty until the Second World War, when it was used by the army. After the war it remained empty, although alternative uses were sought for it. After the lead was stolen from the roof, the then owner, CWD Chaytor, sold it to Baharie Brothers of Sunderland who demolished it. The stables and clock tower survive. The Chaytors are still seated at Croft Old Hall, having returned there from Clervaux.

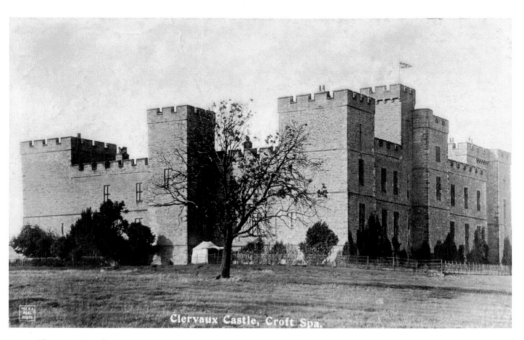

Clervaux Castle.

Clints Hall, Swaledale

Clints Hall stood not far from the village of Marske. The property of the Lords of Marske, it was the seat of a family that took its name from the place, which itself means 'cliff' in Danish. In 1590 Arthur Phillip sold the Clints estate to John Bradley, on whose death it was divided between his daughters. By the end of the sixteenth century it was the seat of Robert Willance, a wealthy Richmond draper. According to local legend:

> In the year 1606 [Robert Willance] was hunting near his own estate, on the high ground between Clints and Richmond, on the northern bank of the [river] Swale. The hunting party were surprised by a fog, and Willance was mounted on a young and fractious horse. To his horror it ran away with him, and made right for the precipitous rock called Whitcliffe Scar, which looks down upon the Swale. The horse, no doubt, as it neared the verge would become conscious of its peril; but, as is very frequently the case, the danger that paralyses the rider only makes the steed more fearless. As soon as it left the level platform above, three bounds, each covering twenty four feet, brought it to the verge of the cliff, down which it sprang. About one hundred feet from the top of the scar there is a projecting mass of rock and earth, upon which the horse alighted, only to throw itself upon the ground below, some hundred feet further down. It was killed by the fall, and Willance's leg was broken. With wonderful presence of mind, he disentangled himself from his dead horse, and, drawing a clasp knife, he slit open the belly of the animal, and laid within it his fractured leg, to protect it from the cold until help arrived. This precaution, in all probability, saved his life. His leg, however, was amputated and he would hunt no more.

To mark his miraculous escape, Willance erected a stone at the point of each of his horse's monumental leaps, two of which were engraved '1606 Glory to our merciful God, who miraculously preserved me from danger so great'.

Clints Hall.

Clints passed to Brian Willance, Robert's nephew, and then to Brian's daughter Elizabeth, who married Charles Bathurst MD. In 1720, when Samuel Buck drew Clints, it was the property of a later Charles Bathurst. It was originally a small three-bay house with a castellated parapet, the centre bay projecting to form a porch. Buck's sketch suggests a sixteenth- or seventeenth-century building. On his death in 1740 Bathurst left the property to his three sisters, one of whom was Jane, wife of William Turner of Kirkleatham. In 1761, Charles Turner (Jane's son) purchased the house outright and almost immediately commissioned Carr to extend and improve the house, producing a much larger roughcast mansion.

In 1767, Turner sold Clints to Viscount Downe, who in turn sold it the following year to Miles Stapleton of Drax. The Stapleton trustees sold the house to Thomas Errington in 1800. Errington made many changes to the house before leaving it to his son Michael, who sold Clints to Thomas Hutton of Marske Hall in 1842. Hutton demolished Clints, leaving only a few ancillary buildings.

Cowesby Hall, Cowesby

At the end of the seventeenth century, Cowesby belonged to Nathaniel Crew, 3rd Baron Crew, who founded Cowesby Hospital nearby for the treatment of impoverished estate workers. George Lloyd bought the Cowesby estate from Thomas Alston in 1832 and immediately entrusted the design of a new house to Anthony Salvin. The resulting house was an engaging Gothic pile with a staircase tower, multiple gables and irregularly placed Tudor-style chimneys.

On George Lloyd's death in 1844 the estate passed to his eldest son, Thomas, on whose death it was inherited by his nephew William. In 1921 the house was sold to Norman Adams, whose twelve-year-old daughter ran her own harrier pack. The house was sold again in 1926, becoming the home of the Gott family. William 'Strafer' Gott inherited Cowesby in 1941. As acting Lieutenant-General, Gott led XIII Corps in the battles of Gazala and First Alamein. He was promoted to command the Eighth Army in 1942, but was killed in a plane crash before taking up the post. The estate was sold in 1946, and in 1949 the hall was demolished and replaced by a new house on a smaller scale to the design of E. Lawson. The estate has had a number of owners since, including the supermarket Morrisons and Camerons Brewery families. The stables survive.

Dalby Hall, Dalby

Dalby was a H-plan house, probably of the seventeenth century, which was extensively altered in the eighteenth or nineteenth centuries. After long being the seat of the Lumleys, Dalby remained with their relations, the Eubanks, until the mid-nineteenth century. By 1890, Dalby Hall had become a farmhouse and was part of the Wiganthorpe estate. Tenanted for many years, Dalby was derelict by the 1960s. In 1961 the new owners were informed that restoration would be as expensive as building a new house. As a result, Dalby was demolished and a new house stands on the site. The eighteenth-century stables survive.

Danby Castle, Danby

The fourteenth-century Danby Castle was built by the Latimers, who owned it until 1381 when it passed to the Nevilles. John Neville, Lord Latimer of Danby, married Catherine Parr, last wife of Henry VIII, and made the castle their home. It later passed by marriage to the Danvers family, with Sir Henry Danvers being created Earl of Danby. It was sold in 1656 to John Dawnay, whose descendants still own it as part of their estate centred on Wykeham Abbey. The castle is built around a courtyard, with a tower projecting diagonally at each corner. The south-east tower is now a farmhouse, which has been extended; the south-west tower is mostly demolished. The original kitchen stands between the two northern towers, with the ruined great hall (largely demolished in 1745) along the east side of the former courtyard. The west range has also been demolished. Adjoining the present farmhouse is a range with a tunnel-vaulted cellar, former great hall and solar, which comprise the former south range. The solar was later used as a courtroom and retains an Elizabethan justice's throne. In the nineteenth century, Danby was the living quarters of Revd John Atkinson, who wrote *Forty Years in a Moorland Parish*. The Court Leet still meets annually at Danby Castle to manage common rights in the parish, and the castle is a popular wedding venue.

Drax Abbey, Drax

The house Drax Abbey stood near the ruins of Drax Priory, founded as a House of Augustinians by William Paynel between 1130 and 1139. The house was demolished in the early 1950s.

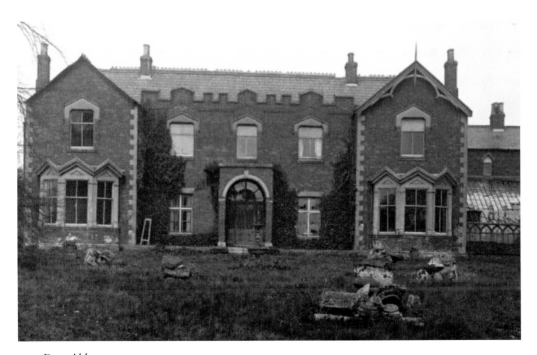

Drax Abbey.

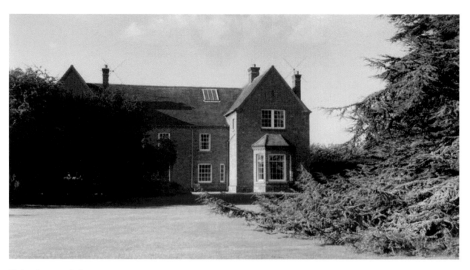

Dringhouses Manor.

Dringhouses Manor, York

In 1718 the manor of Dringhouses was bought by the Barlow family of Middlethorpe. It was in the ownership of the Wilkinsons by 1890 and on the death of Colonel Eason Wilkinson in 1941 the estate was sold off in various lots. The house was bought and reclad in brick by F. W. Shepherd, whose family sold it to Trust House Hotels. The house was demolished in 1966. Some garden features survive.

Duke's Hall, York

Duke's Hall was the Duke of Buckingham's seat in York. Built around 1620, it had nine bays under prominent Dutch gables. By the late eighteenth century, it was ruinous. Buckingham Street marks its site.

Duke's Hall (top right).

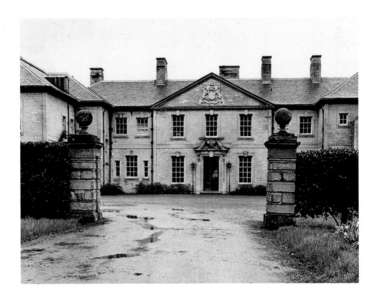

Easthorpe Hall.

Easthorpe Hall, Amotherby

Easthorpe Hall, built on an ancient site, was a seat of the Hebden family. The park had been walled by Lord Eure in 1617–20 and James Hebden rebuilt or remodelled the old house in the middle of the eighteenth century. Long attributed to Carr, the new house may have been by Thomas Atkinson. The rather severe garden front had a massive canted bay with arched windows with rusticated surrounds on each of the bay's ground-floor faces, along with Venetian windows on either side. The first-floor windows, also with rustication, were more conventional.

On the death of James Hebden's grandson, the house was sold and the land incorporated into the Castle Howard estate. During the nineteenth century, Easthorpe was tenanted. Charles Dickens was entertained there in 1843 by Charles Smithson.

In 1926, Easthorpe was hugely enlarged by Walter Brierley for Sir Thomas Beckett, 3rd Lord Grimthorpe, a member of a Leeds banking family. The alterations included a new entrance front with the Grimthorpe arms in the pediment. The Beckett family sold the house in 1965, after which it was a nightclub until it was burnt down in 1971.

Egglestone Abbey, Barnard Castle

Egglestone Abbey was a Premonstratensian House founded around 1896 on a promontory above the River Tees. Following the suppression of the monasteries the abbey was acquired by Robert Strelley in 1548, who converted the east wing of the former abbey buildings into a house, using the refectory as his great hall and inserting mullioned windows.

In 1770 Sir Thomas Robinson sold the abbey to John Morritt of nearby Rokeby Hall. The mansion fell into ruin in the nineteenth century and the Morritt family placed the ruins in the guardianship of the state in 1925. A collection of

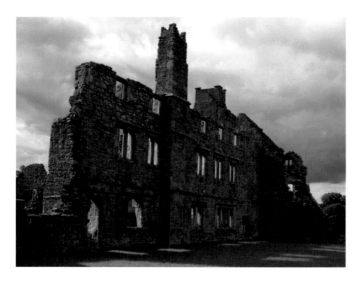

Egglestone Abbey,
Robert Strelley's
house.

architectural stonework, including the tomb of Sir Ralph Bowes, who died in 1482, was returned to the church.

Fewston New Hall, near Tadcaster
Once a seat of the Fairfax family, Fewston Hall now lies under Fewston Reservoir.

Fulford Field House, York
Probably built in the early nineteenth century, Fulford Field House had become Mrs Armstrong's Ladies' School by the 1860s and remained in educational use thereafter. A lodge survives and, appropriately, the site is now occupied by a school.

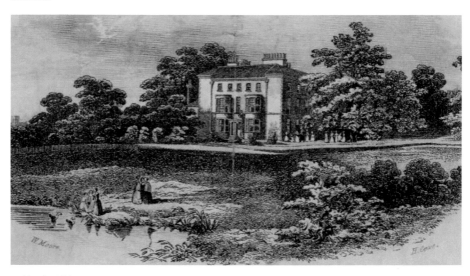

Fulford Field House.

Fulford Lodge.

Fulford Lodge, York
A neat early nineteenth-century villa, Fulford Lodge was renamed Kilburn House by Joseph Agar, a York tanner and city alderman. Agar named his house after his home village, not far from the city, but it is said locally that when developers redeveloped the land in the 1930s they had only heard of Kilburn in London and so named the new roads after other London suburbs.

Gatherley Castle, Middleton Tyas
Demolished in 1963, Gatherley Castle was a castellated mansion and probably dated to 1830–40. Its owner in the 1870s was Sir Henry de Burgh Lawson, a descendant of the Lawsons of Brough, and from 1892 it was Mr Coatsworth of Darlington. Gatherley was bought by Mary Barmingham, daughter of a Darlington ironmaster, in 1900. After her death it was unoccupied, although it was requisitioned during the Second World War and used to house German and Italian prisoners of war as well as a searchlight battery.

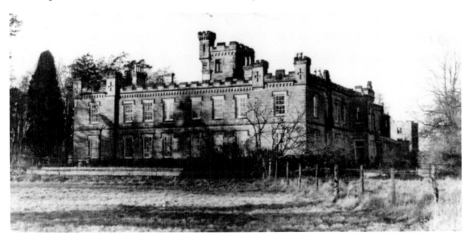

Gatherley Castle.

Gatherley Castle was demolished in 1963 by the developer Edgar Lawson, who is said to have used some of the stone, including a piece bearing a coat of arms, to build his own residence in nearby Darlington. Two lodges dated 1900 stood derelict by the side of the A1 until demolished as part of a road-widening scheme. A local rumour that the castle was dismantled and shipped to the United States for reconstruction can be discounted. Part of the stable courtyard survives, as, apparently, do the castle cellars.

Gillingwood Hall, Gilling West

William I granted Gilling to Alan Rufus, who abandoned the castle there, claiming it insecure, and built Richmond Castle instead. The manor eventually reverted to the Crown and was granted by Henry VIII in 1519 to Sir John Norton. The last Norton to own the manor was Richard, commemorated by Wordsworth in *The White Doe of Rylstone*, who lost his lands after rising against Elizabeth I and died in exile in France in 1585.

Towards the end of the sixteenth century Gilling was bought by the Wharton family. Their seat Gillingwood Hall (sketched by Buck in 1720) was an early seventeenth-century house in the manner of Gainford Hall or Chastleton (Oxfordshire). It seems likely that it was rebuilt in the mid-eighteenth century, as the present Gillingwood Hall farmhouse has a Doric pedimented doorway from the hall and a summerhouse and pavilion (the Bell Park pavilion) also survive. Garrett has been suggested as the architect of the new hall.

The most notorious of the Whartons was Phillip Duke of Wharton (1698–1731), president of the Hell Fire Club, who Alexander Pope described as being 'from no vice exempt'. The hall burnt down in 1750, allegedly after its occupier, Margaret Wharton, got drunk on finding that the house had not been bequeathed to her by her brother. An alternative tale tells how the housekeeper burnt down the house to disguise her thefts from the family. Margaret is said to have lived on at Gillingwood, spending only 1 penny at a time and earning the nickname 'Peg Pennyworth'. Her ghost is reputed to wander through an old house in Thirsk. The earthworks of terraced gardens survive. The present Gillingwood Hall is a farmhouse built around 1800. The Gilling estate still belongs to the heirs of the Whartons and is held in a family trust.

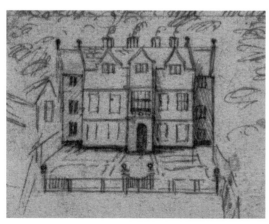

Gillingwood Hall in 1720.

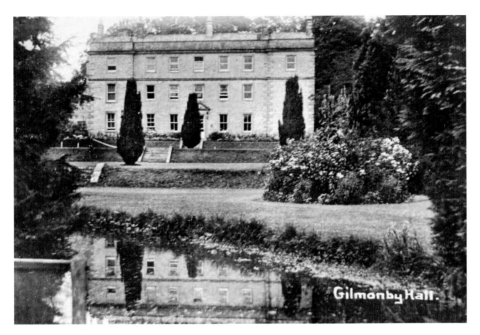

Gilmonby Hall.

Gilmonby Hall, Bowes

Originally a property of the monastery and convent of St Mary's at York, at the Dissolution of the Monasteries Gilmonby passed to John Halylee. In 1624 it was bought by Christopher Whytell, and in 1786 John Whytell sold the estate to Joseph Lyon. Thirty years later, it was purchased by the Headlam family. Gilmonby Hall was a fine classical house of seven bays and three storeys with a central pedimented entrance and rusticated quoins. Gilmonby remained the seat of the Headlams until 1904.

An old Teesdale family, the Headlams became wealthy from the proceeds of shipbuilding at Stockton-on-Tees and Gateshead. The hall owed its final form to Thomas Emerson Headlam, who left shipbuilding to return to Gilmonby. During most of the tenure of his son, John, archdeacon of Richmond, the house was let, being used as, amongst other things, a school and a farmhouse (some farmhouse!). A second Thomas, son of the archdeacon, lived intermittently at Gilmonby, developing the gardens and adding terraces and a lake. In 1904 the house was sold to the Dugdale family. It was requisitioned during the Second World War and demolished shortly afterwards.

Glen Heworth, York

A large but undistinguished 'cottage orné' dating from various periods from the 1850s onwards. Glen Heworth, later known as The Glen, was demolished in the 1960s. Its various owners included William Leak, founder of Leak and Thorp, known as 'York's Selfridges', which closed in the 1980s. In its later years it was used as a children's home.

Glen Heworth.

Government House, Clifton

Known as Ousecliffe until bought by the army in 1907 as Headquarters Northern Command, the house was built in the 1850s for the lawyer William Hudson to the designs of J. B. and W. Atkinson. It was built of white brick with a prominent tower.

Government House.

Green Hammerton Hall, Green Hammerton

This hall, demolished in 1952, stood on the site of an ancient manor house. In the seventeenth century its occupants included the Liddells and the Stockdales. Dowager Lady Clifford bought the house in 1809 and carried out enlargements. In 1853, Revd Richard Ridley left the house to his nephew, who carried out further work between 1867 and 1868. A mansard roof was added, together with a rather feeble French-style tower and lower asymmetrical wings to each side.

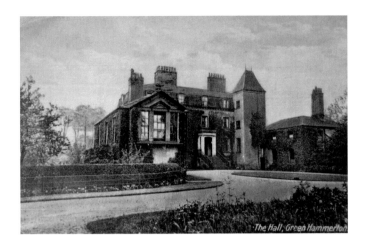

Green Hammerton
Hall.

Green, The (Yorke House), Richmond

The Green, a severe late seventeenth-century building, is shown on Buck's view of
Richmond in 1749. Within seventy-five years it had been demolished. The home
of the Yorkes from 1659, The Green had extensive gardens and grounds, with
tree-lined avenues, summerhouses and the Culloden Tower (1746) by Daniel
Garrett, built for John Yorke to commemorate the Duke of Cumberland's victory.
Many of these features were later lost when the grounds were landscaped. John
Yorke was succeeded by his brother Thomas in 1757, and Thomas by his son
John in 1770. In 1770 a visitor commented, 'Mr Yorke's gardens are very well
worth seeing, as the beauty of the situation is not only naturally great but much
improved by art.'

The last Yorke to live in the house was John, who died in 1813. His nephew
sold it in 1823 to pay debts and it was demolished the following year, though the
stables survived into the age of photography. Culloden Tower is now owned by
the Landmark Trust and is available for holiday lets. Only a set of gates serves as a
memory of the once extensive garden.

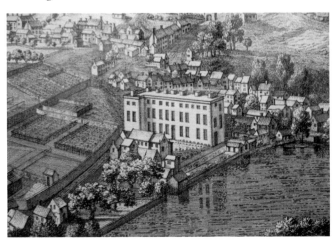

The Green, Richmond.

Guisborough Old Hall, Guisborough

The manor of Guisborough and the site of Guisborough Priory were acquired by Sir Thomas Chaloner after the Dissolution. Chaloner built a new house near the ruins and his grandson Sir William Chaloner added a new wing. The house was set in extensive formal gardens, which are shown in an engraving by Knyff and Kip of 1707. This formal setting was swept away in the eighteenth century. The Old Hall was sold by Robert Chaloner in 1805 and demolished for building materials. The Chaloners moved to a farmhouse, Long Hull, on the site of the present Guisborough Hall.

Gunnergate Hall, Marton Middlesbrough

The first Gunnergate Hall was built in the early years of the nineteenth century. After being occupied by David Appleton, it was bought in 1857 by Charles Leatham, a Quaker and partner in a local iron foundry. Leatham immediately replaced the house to the designs of J. P. Pritchett of Darlington.

The hall was bought by the ironmaster John Vaughan after Leatham's death at the age of thirty-three in 1858. Vaughan died in 1868 and the house was inherited by his son Thomas, who enlarged it between 1868 and 1874, spending so lavishly that he bankrupted the estate and ruined the business. Vaughan's company folded in 1879 and the house was bought by Carl Bolckow, heir of Vaughan's business partner in 1881. With the decline of Bolckow's business, the house was sold to Middlesbrough mayor and shipbuilder Sir Raylton Dixon in 1888. Following the death of Dixon's widow, Gunnergate remained empty except for occupation by the army during both world wars. It was demolished in 1946 and the land acquired by Middlesborough Council. Two of the property's lodges survive. A nature reserve has been created in the former grounds.

Gunnergate Hall.

Halnaby Hall, Croft

Lady Dorothy Milbanke was a favourite courtier of Mary, Queen of Scots, who became involved in the scandal surrounding the murder of David Rizzio by Lord Darnley. Lady Dorothy fled, becoming penniless and selling gingerbread on Berwick Bridge. Fortunately, she was eventually able to restore the family fortunes. Her son, Sir Mark Milbanke, became Lord Mayor of Newcastle and bought the Halnaby estate from Sir Francis Boynton in 1649. The house had passed to Boynton through the female line from the Place family in 1633, Robert Place having gained Halnaby on his marriage to Katherine, last of the Halnabys in 1410. Parts of the ancient house survived in the service quarters of the later Halnaby Hall.

Either the purchaser of the estate, Sir Mark, or his son, also Sir Mark (d. 1680), chose to rebuild the old house around 1660. The new mansion was tall and square with classical detailing; the entrance was through a two-storey pillared porch with Doric details on the ground floor, Ionic at first-floor level and Corinthian around the second-floor window. A lower wing was added to the east of the house around the turn of the seventeenth century and the fenestration of the lower floors was changed to sashes.

In 1728, Sir Ralph Milbanke, 4th Baronet, added the west wing, restoring the symmetry of the house. Sir Ralph married Anne Delaval of Seaton Delaval, and it

Halnaby Hall.

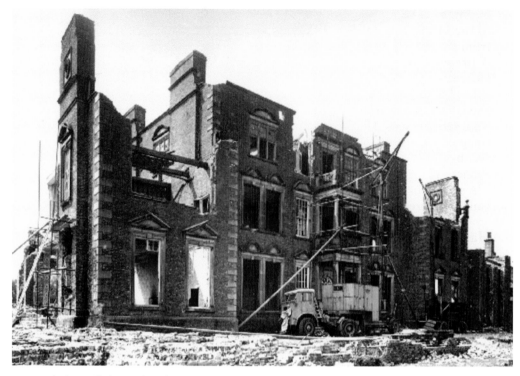

Halnaby Hall during demolition.

has been suggested that Vanburgh worked at Halnaby. Striking as the west wing is, with dramatic chimneys apparently pierced at first-floor level by windows (blank but glazed) and flanking a canted bay, there is nothing to suggest the hand of Vanburgh, and in any event the wing appears to have been finished before the marriage. Rococo plasterwork was added to the hall (which became the dining room when the entrance was moved to the opposite side of the house) in the mid-eighteenth century by a later Sir Ralph. In the 1840s the staircase was remodelled in the style of the early eighteenth century.

The estate was sold in 1842 by the Milbank family on the death of Sir Ralph Noel (formerly Milbanke, and Lady Byron's father) to John Todd. Todd's daughter married Captain W. H. Wilson and the Halnaby estate remained with the Wilson Todds until the 1940s when Lady Wilson Todd sold the estate to G. N. Gregory, who in turn put it up for sale in 1951. No buyer was found and as a result fixtures and fittings were removed and the house was demolished in 1952, despite strenuous efforts to save it.

Halnaby was one of the few houses of utmost importance that North Yorkshire has lost. Fragments of the late seventeenth- or early eighteenth-century service wing remain and have been converted into a house. A range of garages, coach houses and 'motor houses' built in 1910 around three sides of a courtyard has been converted into bed and breakfast accommodation. Much of the site of the hall has been irretrievably spoilt by utilitarian farm

buildings. The majority of the dining room plasterwork was transferred to the Bridge Inn, Walshford on the A1 where it remains and plasterwork from the drawing room ceiling is now in Wycliffe Hall, County Durham. A fireplace was purchased by the government and re-sited in Kensington Palace.

Lord Byron spent the honeymoon of his disastrous marriage to a Milbank at Halnaby. 'Good God,' he is alleged to have woken screaming on his wedding night, 'I am surely in hell'. The Byrons' only child, Ada, later Countess of Lovelace and a computer pioneer (the language ADA is named after her), was born later the same year by which time Byron had fled to Greece. The Milbanke Halnaby baronetcy is extinct, although Milbanks continue to be seated at Barningham Hall.

A sundial base, said to have been designed by Inigo Jones, that was formerly at Halnaby is preserved in Darlington's South Park.

Haxby Hall, Haxby

Although Haxby Hall stood on Haxby high street, from the rear it was entirely rural. The hall was originally built around 1790 but it was remodelled for J. T. Tuite in the late 1820s when a semicircular portico was added. The central block was of five bays, with the centre being two and a half storeys and the outer bays two storeys. There were extensive stables and service buildings and the grounds extended to 11 acres. The garden front was a good deal less coherent than that facing the street, but included a glass dome over the staircase.

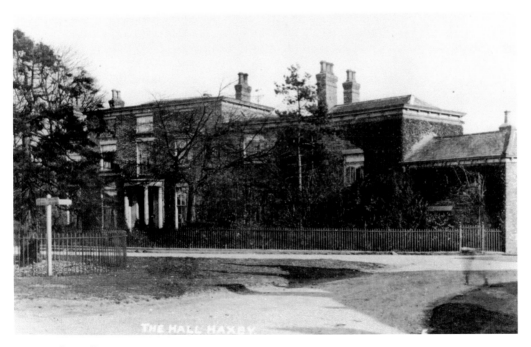

Haxby Hall.

Between the wars Haxby was bought by Mr Kenneth Ward, although during the Second World War it was requisitioned, Mr Ward moving back in at the end of hostilities. By the time he sold the house in 1950 only about 3 acres remained, the rest having been sold for housing development. The house was converted into flats and more land was subsequently sold.

A roundabout was built outside the front door of the hall which was later demolished by York Council after a survey revealed that the building was no longer sound. A fire station was built on the site together with an old people's home bearing the name Haxby Hall. Nothing but fragments of railing remain.

Heworth Cottage, York

Despite its name, Heworth Cottage was a substantial seventeenth-century house which belonged to the Kilvington family until 1736. A later owner, Thomas Bond, left the house to his daughter who in turn left it to Lucy Willey, who built Heworth Hall in its grounds. Heworth Cottage was demolished in the 1930s.

Heworth Hall, York

Heworth Hall was a classical villa of about 1830 that was built for Mrs Lucy Willey and her husband, curate of St Cuthbert's. Later home to Lady Milbanke, the house and substantial grounds were sold for development in 1928. The hall was demolished in 1934 and is now commemorated by Heworth Hall Drive.

Heworth Old Manor House, York

By the reign of Henry VIII, Heworth Manor was the seat of the Thwenge family. In 1678 the property was bought by Sir Thomas Gascoigne for his niece Ellen Thwenge, whose father had been forced to sell it to the Agars due to financial difficulties. Both house and family were involved in the 'Barnbow Plot'. Helen Thwenge's brother, the priest Thomas Thwing, was chaplain at Heworth and was arrested there in 1679 before his martyrdom. During the nineteenth century the manor house, which has long been demolished, was owned by the Hornby family.

Heworth Place, York

Built before 1843, Heworth Place was later known as The Pleasaunce. Initially a private residence, it later became an asylum before it was demolished in the 1930s.

Hildenley Hall, Hildenley

Hildenley Hall was built around 1620 for the descendants of William Strickland, who had acquired the estate in 1565. The house was later enlarged and the west wing bore the date '1768'. The house was sold following the death of Sir Charles Strickland in 1909. The new owner was Honourable Francis Dawnay. Hildenley was largely demolished in 1927–31, although ruins remain, including those of the last Strickland owner's orchid houses.

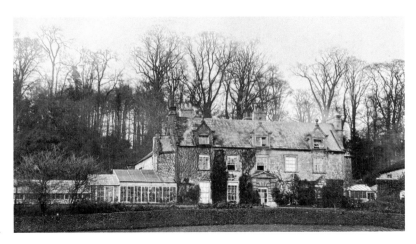

Hildenley Hall.

Holbeck Hall, Scarborough

Holbeck Hall, then known as Wheatcroft Cliff, was a medium-sized mock-Tudor house built in 1879 by George Alderson-Smith, a steam trawler owner. Alderson-Smith was also chairman of the Grand Hotel Company and the South Cliff Tramway Company, and a director of the Scarborough Spa Company. Three of his trawlers were sunk by enemy submarines during the First World War. Alderson-Smith died in 1931 and in June 1932 Wheatcroft Cliff was bought by Messrs Laughton, the proprietors of the nearby Pavilion Hotel, who converted it into the Holgate Hall Hotel at considerable expense, including the addition of a new wing. Robert Laughton, the new owner, was the brother of the actor Charles Laughton. Holgate Hall's recent claim to some degree of fame occurred in 1993 when land subsidence caused it to fall into the sea in a matter of days.

Holgate Lodge, York

Holgate Lodge was built by Thomas Simpson, a Knaresborough doctor, shortly after he purchased land at Holgate in 1827. After Simpson's death in 1863, the property

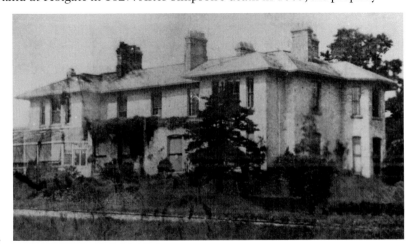

Holgate Lodge.

was bought by John Gutch and his wife Eliza. Gutch was a lawyer and he and his wife gradually built up a small estate. Eliza Gutch died in 1931, fifty years after her husband, and the house was demolished and the land sold for residential development.

Holgate Villa, York
Replaced by an office block in the 1960s, Holgate Villa was built around 1840 by the London & North Midland Railway to provide accommodation for its engineers.

Hornby Castle, Hornby
The pele built by the St Quentins in the thirteenth century became one corner of the mansion built around a courtyard by later owners. Hornby passed to John Conyers through his wife Margaret at the end of the fourteenth century and thereafter remained the principal seat of the Conyers. Sir John Conyers, favourite of Henry VII, married a Neville, as did his grandson William, 1st Lord Conyers, who rebuilt the house on a palatial scale around 1500 after his marriage to Anne, daughter of Ralph Neville, 3rd Earl of Westmoreland. Lord Conyers is said to have fought at Flodden and undoubtedly entertained Lady Margaret Tudor in great style at Hornby in 1503.

In the seventeenth century, Hornby passed by marriage to the D'Arcy family when Elizabeth Conyers married Thomas D'Arcy, whose grandfather had been executed on Tower Hill for his part in the Pilgrimage of Grace. Three successive owners, each called Conyers D'Arcy, sat as MPs. The first, son of Thomas Darcy, was made a baron, while the middle one was raised to the peerage as Earl of Holderness.

The house was built around a courtyard plan with a keep-like tower at the north-west corner and the St Quentin Tower at the south-east. The main entrance was

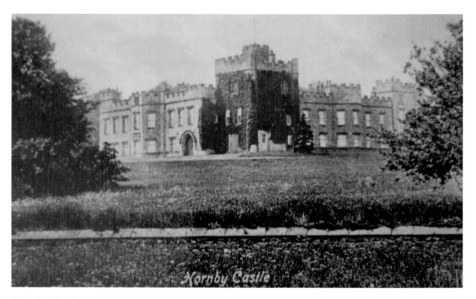

Hornby Castle.

through a doorway on the north side of the courtyard, with the arms of Conyers carved above it, which is now in Glasgow's Burrell Collection. The north range, extending from the keep-like tower contained the great hall or saloon, which probably attained its final form in the early years of the eighteenth century when the castle was the seat of the 3rd Earl of Holderness. Robert Darcy, the 4th Earl and Lord of the Bedchamber to George II, who succeeded aged three in 1722, reconstructed the rest of the castle. In the 1760s the ubiquitous John Carr remodelled the east range, which contained the private apartments, and the south range, which contained a library and billiard rooms, with a drawing room above in the Gothic style. The south range also contained the arched entrance to the courtyard. The west wing contained the state rooms. It is likely that some work was carried out by James 'Athenian' Stuart in the 1750s and Ignatius Bonomi may also have been involved.

Holderness died in 1778 when the earldom became extinct (both his sons had died young) and Hornby passed to his daughter Amelia, Baroness Conyers, who married the 5th Duke of Leeds but eloped with Captain John Byron, father of the poet. The estate and castle were sold by the 11th Duke of Leeds in 1930 and bought by a Mr John Todd of nearby Northallerton, who broke up the estate and sold the contents of the castle, which was subsequently largely demolished, only one of the four ranges surviving. Some of the architectural features were bought by William Randolph Hurst, but they were still in crates when he died in 1950. Shortly afterwards they were sold to Sir William Burrell, and they are now in the Burrell Collection in Glasgow.

Only the south wing, which is essentially Georgian with some earlier features, survives. This wing has been enlarged to form a new country house for the Clutterbuck family. Much of the appearance of the park has been preserved and still gives the appearance of being the demesne of a great house.

Huby (Old) Hall, Huby

A fragment of Huby Hall, with brick pilasters and a Dutch gable, survives. The original hall was much larger but was in ruins by the nineteenth century. In 1720 Huby Hall was sold to William Wakefield, the distinguished amateur architect.

Huby Old Hall.

Hutton Bonville Hall, Northallerton

Hutton Bonville stood close to the small church of St Lawrence near the River Wiske, the village of Hutton Bonville having long since disappeared. An older house was remodelled in the first quarter of the eighteenth century to produce a symmetrical ashlar mansion with an entrance front of three deeply recessed central bays and projecting three-bay wings. Behind this front, which had a balustraded parapet, the older house appears to have survived largely intact.

Anciently the seat of the Conyers, in 1699 Hutton Bonville was the seat of Richard Pierce. By 1720 it had passed to his second son, Thomas. In 1785 Thomas' grandson sold the estate to Anthony Hammond of Richmond, who in turn sold it in 1820 to Henry Pierse MP. Pierse died in 1824 and the estate passed to his daughter Harriet, who married Sir John Beresford.

During the early nineteenth century, Hutton Bonville was given a Gothic makeover. The centre of the front entrance was filled in and a central tower with corner turrets was built. In 1859 the Beresford-Pierses sold the estate to John Hildyard, who made extensive additions to the servants' quarters to the designs of Eden Nesfield in 1879–80. The owner in the 1890s was John Arundell Hildyard, who moved to Horsley Hall, County Durham, in 1920. In 1921 the estate was bought by a syndicate and the farms sold to the tenants. The hall remained empty and passed through a number of hands, during which time Nesfield's additions were removed. What was left of the hall was bought by Miss V. D. Hildyard of Bolton-on-Swale, who left it to her sister Cicely Hildyard. Cicely never lived there

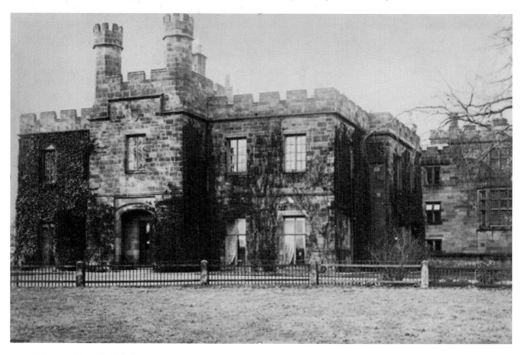

Hutton Bonville Hall.

but left it in turn to Christopher Ringrose-Wharton of Skelton Castle. Hutton Bonville was demolished around 1970.

Keldy Castle, near Pickering
The Hull banker William Liddell bought the farmhouse known as Keldy Grange with 266 acres in 1810. He proceeded to build a castellated block with a two-storey bay window and a number of turrets of various sizes. The castle has been attributed to Henry Hakewell, architect of Cave Castle. Liddell and his heirs continued to buy land, eventually accumulating an estate of more than 8,000 acres. The Liddells used Keldy as a holiday home until they sold it in 1893 to Sir James Reckitt, the Hull industrialist whose fortune came from Reckitt and Colman, founded by his father. In 1900 the estate was given as a wedding present to Sir James' second son, Phillip, on his marriage to Hilda Grotian. Phillip Reckitt first added a new block and then in 1910 effectively rebuilt the castle to the designs of John Bilson of Hull. The result was a rather conventional Tudor-style house of four bays flanked by projecting wings; there was also a large square central tower. Elaborate gardens were also laid out. During the Second World War the house was requisitioned by the army. In 1946, two years after Philip Reckitt's death, his executors sold the house to the Forestry Commission for use as a training school. This plan was later abandoned and, unwanted, Keldy was demolished in 1950.

Kirkleatham Hall, Middlesbrough
Kirkleatham is a haunted place. Amongst the industrial sprawl of the Tees valley, it is a reminder of its former loveliness. This small area of the Riding was the setting for a rich group of houses including Wilton Castle, Upleatham Hall, Skelton Castle, Rushpool Hall and, most significant of all, and now lost, Kirkleatham Hall.

William I granted Kirkleatham to Robert de Brus, who gave it to William de Perci. Later owners included the notable local families of Thweng, Lumley and Bellasis. The Kirkleatham estate was purchased from William Bellasis by John Turner in 1623. Turner was a Herefordshire man who came to the north as manager of Sir Thomas Chaloner's alum mines near Guisborough. For the remainder of his life he acquired land in the area, establishing the estate his descendants would hold for generations. Thomas' son John (1613–88) probably built a new H-plan house with a cupola and Dutch gables, although it is possible that he remodelled an earlier house built by his father. Appointed Sergeant at Law, John married a cousin of Samuel Pepys.

The younger John Turner's brother, Sir William, Master of the Merchant Tailors Guild, was Lord Mayor of London in 1699 and later MP for the City of London. Amassing a considerable fortune, he endowed and built a set of arms houses (Turner's Hospital) near the hall in 1676 to designs by Robert Hooke.

The estate passed to Charles Turner (1650–1719) and his son Cholmley (1685–57), whose elder brother William had died in 1702. Cholmley built Kirkleatham Free School, now known as Kirkleatham Old Hall Museum, in accordance with the wishes of his great-uncle Sir William. On the death of his

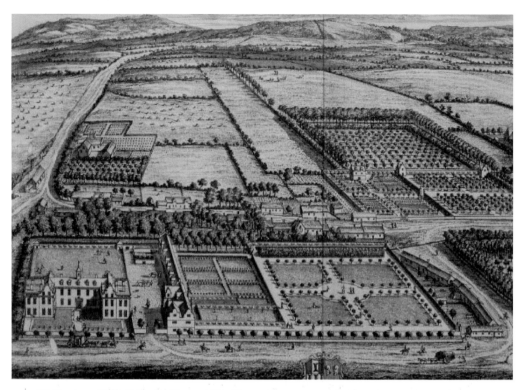

Kirkleatham Hall. (Print by Kip and Knyff)

father, Chomley and his wife Jane moved from her family estate, Busby Hall, to Kirkleatham. Cholmley subsequently pursued a successful political career as MP for Northallerton and later Yorkshire.

In the 1720s Chomley Turner commissioned plans from the architect James Gibbs for a huge new house. This house was never built, alterations to the existing hall being made instead. In 1739 the Turners' son, Marwood, died of typhus or cholera on the grand tour. As a result, his parents commissioned the extraordinary mausoleum that still stands as part of the parish church. Whilst working on the mausoleum Gibbs also made major additions to the nearby Turner's Hospital, completely rebuilding the chapel and altering the stables. The statues that grace the building have been ascribed to Scheemakers but are probably the work of John Cheere. The figure of Justice in the courtyard, as well as some chapel fittings, may have been brought from the Duke of Chandos' lost mansion of Canons. The hospital is now run by charitable trustees and still provides a home for ten single men and ten single women over the age of sixty-three.

In 1764, Charles Turner (1727–83), nephew of Cholmley, who became 1st Baronet in 1782, commissioned John Carr to remodel Kirkleatham. Carr filled in the space between the wings of the 'H' and added new wings to the east with a large bay window. Unusually for Carr, the roughcast brick house was Gothic in style. The east wing of the house contained a gallery 60 feet long, entered through

a Corinthian doorcase said to have been designed by Sir William Chambers. Other interiors included a Chinese room and a double-height dining hall. Carr was probably also responsible for the east façade of the stable block.

The earlier house had elaborate formal gardens (illustrated in a print by Knyff and Kip); these were landscaped in the eighteenth century and included grottoes, cascades, temples and a dovecote.

Sir Charles Turner's son, also Sir Charles (2nd Baronet), inherited the estate and was the last Turner to hold it. Sir Charles was at one time owner of the great racehorse Hambletonian, immortalised by Stubbs in his magnificent portrait now at Mount Stuart. On Sir Charles' death in 1810 the estate passed to his wife, Teresa (née Newcomen), and from her to a daughter, also Teresa, by her second marriage to Henry Vansittart who was thus unrelated by blood to the Turners. Teresa Vansittart married her cousin Arthur Newcomen. On his death in 1848 she turned to religion for consolation, founding an Anglican religious community in 1858, the Community of the Holy Rood. The estate passed in turn to her son Arthur Newcomen, her grandson Gleadhowe Newcomen and her granddaughter Kathleen Lewis (sister of Gleadhowe), who died in 1948.

After Mrs Lewis's death the estate passed to her son Henry, who sold it to Ortem Estates Ltd. The contents of the hall were sold and it fell into disrepair after passing through the hands of several owners. It was demolished in 1954. A school now stands on the site.

The grounds have been obliterated but Turner's almshouses and their baroque chapel survive, as do the stables of the 1730s with additions by Carr. The stables are derelict and in very poor condition. A Gothic arch stands nearby.

Gibbs' dramatic mausoleum contains an important series of Turner monuments, including works by Scheemakers, Cheere and Westmacott.

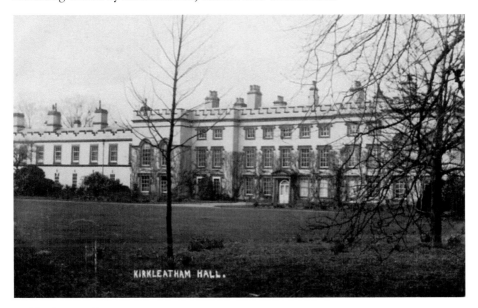

Kirkleatham Hall.

The Old Hall at Linthorpe.

Linthorpe Blue Hall.

Linthorpe Blue Hall, Middlesbrough

Appearing to date from the late seventeenth century, Linthorpe was the seat of Peter Consett. It was sketched by Samuel Buck in around 1720. A three-storey L-shaped house of brick, Linthorpe was demolished in 1870 to make way for the ever-expanding suburbs of Middlesbrough. By the time of its demolition, the hall was probably being used as a farmhouse. Blue Hall was reputedly used by smugglers from Newport. Almost inevitably, there was said to be an underground passage to the manor house at Acklam.

Marton Hall, Marton Middlesbrough

Marton, the 'village on the marsh', was granted to Robert de Brus of nearby Skelton Castle after the Conquest and changed hands repeatedly until it was bought in 1786 by Bartholomew Rudd. Rudd built himself a new house near

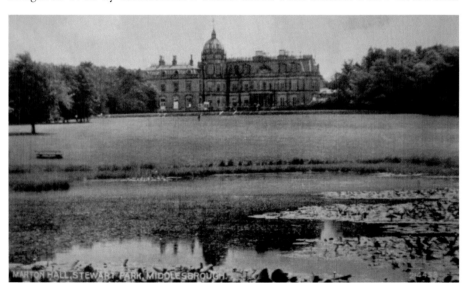

Marton Hall.

the thatched cottage in which Captain James Cook had been born in 1728. Unfortunately, this new house burnt down in 1832 whereupon the Rudds moved to Tollesby Hall, selling Marton to Revd James Park.

Having bought the estate in 1853, the next Marton Hall was built between 1854 and 1857 by the Middlesbrough ironmaster Henry Bolckow, next door to Gunnergate Hall, the home of his friend and colleague John Vaughan. Bolckow was born in Mecklenburg in 1806 and came to England in 1827 when the population of Middlesbrough was forty. By the time he died in 1878 it was almost 56,000. Bolckow became, mayor, a British subject and an MP in turn. Bolckow and Vaughan met in 1830, married two sisters and opened their first ironworks using deposits of ironstone found locally. Bolckow built a huge red-brick house with a long subsidiary range connected to the main block, the junction marked by a domed octagonal tower.

Vaughan died in 1868, the year Bolckow became first mayor of Middlesbrough and entertained Queen Victoria at his new house. Before the royal visit, Bolckow had massively extended his house in the French style with elaborate Italianate interiors. The architect was probably the German Ludwig Martens and the additions included a heavy mansard roof capped with elaborate ornamental balustrading, new window surrounds and dormer windows with caryatids.

On Bolckow's death in 1878, the house, gardens and estate were inherited by his nephew Carl Bolckow, who in 1881 bought the Gunnergate estate as well.

By the 1870s, the Middlesbrough steelworks were losing ground to producers overseas. As a result, in 1888 Carl sold his uncle's picture collection, which included works by most of the great nineteenth-century names, at the same time selling Gunnergate to Sir Raylton Dixon, mayor of Middlesbrough. The house at Marton stood empty for long periods and further sales of contents took place in 1907, 1923 and 1924. During the First World War the house was used to accommodate troops. In 1924, the Marton estate was sold to Thomas Stewart, who presented it and its grounds to the people of Middlesbrough. The hall was briefly a museum, then a fire service headquarters.

Only a colonnade now remains of Marton Hall, which was almost entirely demolished in 1960. During the course of demolition, the house was gutted by fire. The grounds, renamed Stewart Park, are a valuable green space in the South Middlesbrough suburbs.

Captain James Cook, the great explorer, was born in a cottage in Marton village, a site within the Marton estate and now marked with an urn. No sign of the birthplace remains above ground, but the estate is home to the Captain Cook Birthplace Museum.

Meadowfield, Whitby

Meradowfield was the home of the Simpsons, Whitby bankers. The Simpsons were partners in Simpson, Chapman and Co., which was founded by Wakefield Simpson and Abel Chapman in the 1780s and remained independent until 1892 when it was taken over by the York Union Bank. Wakefield was followed by his son, grandson and great-grandson, Henry, who died at Meadowfield in 1893. After Henry Simpson's death, Meadowfield belonged to the Marwoods, a family of shipowners.

Meadowfield.

Meadowfield was a brick house of five bays with a central porch, over which was a strangely proportioned Venetian window. It was probably built by Wakefield Simpson, the founder of the family fortunes. The interiors were much altered in the nineteenth century, resulting in a series of heavy High Victorian schemes with elaborate built-in woodcarving in dark woods. Meadowfield was demolished in the 1950s and the site built over. The lion head door knocker from Meadowfields is now at Porch House in Northallerton, once another Marwood residence.

Middlethorpe Lodge, York
Middlethorpe Lodge was an early nineteenth-century villa to which a tower in the Arts and Crafts style was later added. The house was requisitioned by the army in 1941 and remained in military use until it was demolished in the early 1950s.

Middleton Quernhow Old Hall
All that remains of Middleton Quernhow Old Hall is a fragment of the south wing, although the building was complete, albeit roofless, into the twentieth

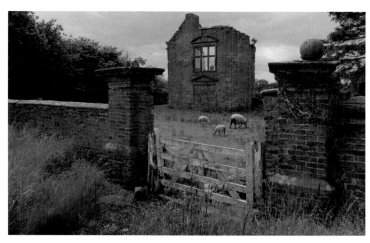

Middleton Quernhow Old Hall.

century. The house dates from the second quarter of the seventeenth century and was once a seat of the Herbert family. A former occupant, Thomas Best, was Member of Parliament for Ripon in the early seventeenth century. A pair of gate piers contemporary with the house also survives.

Newton Hall, Londonderry

The first Newton Hall was built by Revd Warcop in the late eighteenth century after he had formed the estate. It later belonged to Robert Russell, a market gardener whose daughter Elizabeth married the 3rd Earl of Darlington in 1813. The new house, a hunting box on a sumptuous scale, was built for Darlington, later 1st Duke of Cleveland, in 1822–23 by Ignatius Bonomi.

The house was plain but elegant, with a Doric portico and a heavy parapet. There was a long wing to one side with a rather insignificant turret. It is possible that this wing was added by Lewis Vulliamy for the Duchess of Cleveland. On her death in 1866, the duchess left Newton to her great-nephew, Robert Russell, and in 1914 William Derby Russell lived there. During the Second World War the grounds became part of RAF Leeming. The mansion was demolished in 1956 after having been a hotel for a brief period. Little survives now, although the park wall and a beautifully restored lodge still exist on the outskirts of the rather drab village of Londonderry, which stands only yards from the A1. Most of the estate lies beneath the functional buildings of RAF Leeming, which is still an active base.

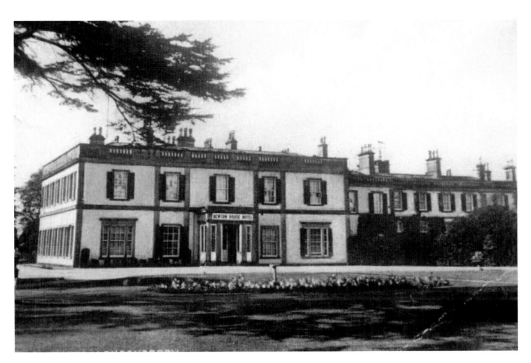

Newton House.

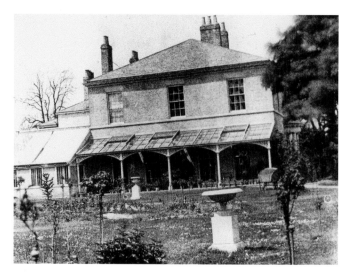

North Lodge.

North Lodge, York

North Lodge was an early nineteenth-century villa that was a victim of the development of the railways. It was demolished in 1873 for York railway station to be built on the site. The Lodge had been let to John Close, Secretary to the York & North Midland Railway under George Hudson and three times Lord Mayor of York, who insisted his company build him a new house elsewhere.

Nunthorpe Hall, York

Nunthorpe Hall probably dated from the third quarter of the nineteenth century. Sir Edward Green lived in the hall after 1888 and ran it as a military hospital during the First World War. The Greens sold the hall before 1921. It was later divided before being demolished in 1977. Flats were built on the site.

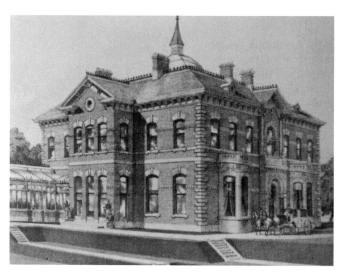

Nunthorpe Hall, York.

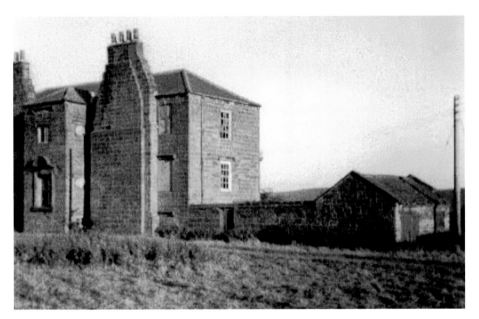

Park House.

Park House, Guisborough

The Chaloners owned the Guisborough estate from 1550. Park House was their first seat before William Chaloner moved to Guisborough Old Hall. Their fortune came from the production of alum, for centuries a monopoly of the pope, and they were eventually bought out by James I. On high ground outside the town, the house stood in a deer park, which was stocked until the eighteenth century. In 1673 the owner was Sir Edward Chaloner and the occupier his son William, who moved to the Old Hall. After the move the house was tenanted, although it was retained in part for use by shooting parties. It was later abandoned, fell into dereliction and was demolished around 1970.

Park House was built of stone and was of three storeys with a projecting central bay on the front containing the entrance. To the rear were two massive chimneys separated by a projecting block with a classical window, lying behind the entrance 'tower' on the other side.

Rounton Grange, East Rounton

Rounton Grange was unique and its demolition in 1954 was one of the most significant architectural losses in Yorkshire. Phillip Webb's masterpiece was built after 1871 for the ironmaster Sir Lothian Bell. Bell had bought the East Rounton estate from John Wailes in 1866 and, after considering enlarging the original farmhouse, elected to commission a new home. The old house was flanked by mature trees, and since Bell wished to retain them the new house was effectively a narrow tower house with corner pavilions of four storeys and recessed centres to each front rising through five. The main 'tower' of sandstone was connected to an enormous service wing with a clock tower.

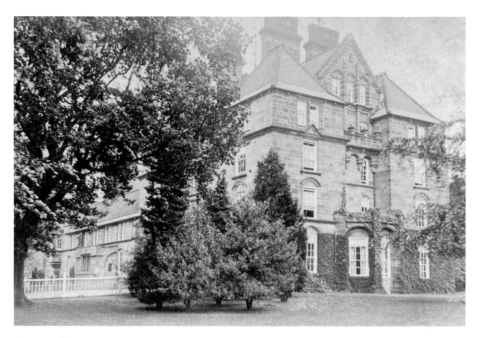

Rounton Grange.

The detailing was eclectic and typically Webb, with Gothic and classical details and a general Arts and Crafts feeling. The planning was perhaps unnecessarily complex, which was also typical of Webb. The main rooms were panelled in oak and the decoration of the dining room was designed by William Morris and Sir Edward Burne-Jones, both friends of the architect. Above the panelling was a tapestry frieze embroidered by Lady Bell and her daughter Florence.

The house was later enlarged by George Jack, Webb's assistant, for Isaac's son Hugh, whose eldest daughter was the famous Arabist and traveller Gertrude Bell. The additions included a huge 'common room' with a barrel-vaulted ceiling, connected to the dining room by a long corridor. Sir Lowthian Bell died in 1904, followed in 1931 by his son Sir Hugh and in 1941 by his grandson. Two sets of death duties sealed the fate of Rounton, and the family moved to Mount Grace. The house was an evacuee home and a hostel for Italian prisoners during the Second World War. Following the war attempts were made to sell Rounton, but without success. The house was offered to the National Trust but could not be accepted without an endowment. It was demolished in 1964, although the family retain the estate and live at nearby Arncliffe Hall. The coach house, home farm, almshouses and other estate and village buildings survive. The estate also had a rest house for the use of ailing members of the Bell workforce in need of a break. Ingleby village contains important Arts and Crafts buildings by George Jack, Walter Brierley and Ambrose Poynter.

Born in 1816 into a family of Jarrow iron founders, Lowthian Bell and his brothers built a huge empire, which at one time produced one third of all the iron and steel used in Britain and employed 47,000 people. Bell Brothers also owned a chemical plant, the first to produce aluminium for commercial use.

Rylstone Hall, Rylstone

Rylstone was the seat of the Norton family until they, like many others, lost everything following the Rising of the North (1569). The estate was dismantled in the seventeenth century and the ruins of the house demolished in the twentieth. Earthworks survive of extensive water gardens, including a rectangular lake with an island to provide shelter for birds. The village of Rylstone is now perhaps most famous for the ladies of the local Women's Institute who produced a famous charity nude calendar and were the subject of the successful film *Calendar Girls*.

Sand Hutton Hall, Sand Hutton

The Sand Hutton estate was not far from Stamford Bridge. The original house was built in 1786 by John Carr for William Read, whose family had owned the estate since at least the beginning of the century. Two storeyed and of white brick with a central bay, Carr's house became the south wing of a much larger mansion. On William's death, Sand Hutton passed to a relative, Revd Thomas Cutler Rudston of Hayton Hall, who added the name of Read to his own. On Rudston-Read's death the house and estate were sold to James Walker, whose family wealth began with his great-grandfather, a Manchester merchant of the early eighteenth century.

James was made a baronet in 1868 and commissioned Anthony Salvin to enlarge the house between 1839 and 1841. Salvin carried out further additions between 1851 and 1852. The 2nd Baronet, another Sir James, inherited in 1883 and largely rebuilt the house shortly afterwards. He was succeeded by a third Sir James, who died in 1900, less than a year after his father and was in turn succeeded by his son, Sir Robert.

Sir Robert inherited the estate at the age of ten. A *bon vivant*, he was also a railway enthusiast who built the Sand Hutton Light Railway with three locomotives named after his wives, one of which – a locomotive, not a wife – is

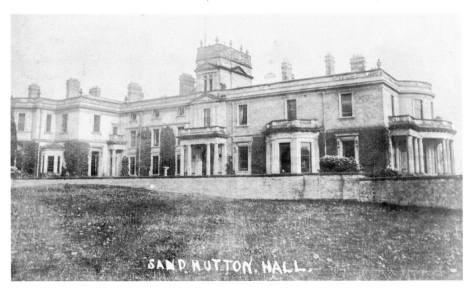

Sand Hutton Hall.

preserved by the Ravenglass and Eskdale Railway in Cumbria. His private fire brigade was largely inactive, but, dressed in uniform and helmet, Sir Robert once hosed down a female guest at a dinner party.

Sir Robert died in 1930 and the estate was sold to the Church Commissioners. The house was retained and used by Polish servicemen during the Second World War. It was sold by the family after the war and in 1955 the new owners sold half the house for materials. The northern part of the house survived as flats until it too was demolished, in 1971. The porch tower and an icehouse survive.

Scriven Park, Knaresborough

Scriven Park, the seat of the Slingsby family since the thirteenth century, was destroyed by fire in 1952. William Slengesby was warden of the manors of the knights of Ribbestayn in 1311, Sir Henry (1st Baronet) was executed in 1658 for plotting the restoration of the monarchy. In the first quarter of the eighteenth century, Sir Henry Slingsby remodelled the old house (described as 'that rotten house at Scriving') and built a superb classical front with an enclosed portico to the design of William Wakefield. Slingsby's sister married Thomas Duncombe of Duncombe Park, where Wakefield also worked.

The last male Slingsby in the direct line was Sir Charles (1824–69), who was drowned when the ferry in which he was crossing the River Ure sank. Slingsby passed to his sister and, after her death in 1899, to Charles Atkinson. Charles Atkinson married an American beauty of dubious reputation, known as 'the Kentucky Belle'. Apparently unable to have children, they went on holiday overseas and returned with a baby. The subsequent unsuccessful legal battle to have the child legitimised bankrupted the substantial estates, which were broken up. During and after the Second World War the hall was requisitioned for thirteen years. After a fire broke out while it was empty, it was finally demolished in 1954. Gate piers as well as the stables and coach house dated 1682 survive, which have been converted into a house. Knaresborough Parish Church contains the Slingsby Chapel, which is home to an important series of memorials.

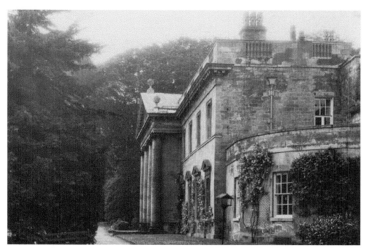

Scriven Park.

Scruton Hall, Scruton

William I gave Scruton to Picot de Lascelles, whose family owned it until the end of the thirteenth century. In 1314 it passed to the Markenfields of Markenfield Hall, and in the seventeenth century to the Danbys of Thorpe Perrow. In 1688 the manor of Scruton was purchased by Dr Thomas Gale, member of the prominent Scruton family, from Sir Anstropus Christopher and Anne Danby. Dr Gale was high master of St Paul's School in London and later Dean of York and married a second cousin of Samuel Pepys.

The final Scruton Hall was built by his son Roger Gale (*c.* 1672–1744) around 1705 as a seven-bay gentleman's house of brick with pedimented entrance and garden fronts. In the last decade of the eighteenth century, Henry Gale (Roger's grandson) carried out a series of improvements to the house, including the insertion of carved fireplaces designed by Henry Foss. Canted bays of two storeys were added to either side of the entrance in the early nineteenth century, and the garden front acquired a completely inappropriate porch with a hipped roof. Henry Gale's daughter married Lt-Col Foster Coore in 1816 and the estate passed to the Coore family when the Gale line failed. Revd Alfred Coore went to India as a missionary in 1898 and, despite being untrained as an architect, he designed around fifty churches, schools and other buildings in a mixture of Indian styles before returning to England. On the death of his brother Alban Coore in 1953 the estate was sold. In 1958 the woodland was cut for timber and the house demolished when no use could be found for it.

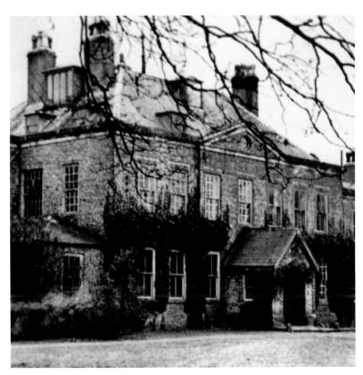

Scruton Hall.

Sedbury Hall, Scotch Corner

The Sedbury estate sits in the apparently unpromising location of Scotch Corner on the A1, but it is in fact nestled at the end of Holmedale, one of the least known of the Yorkshire Dales. The current house was built in 1928 but replaced a much older and more interesting mansion.

In the first half of the fifteenth century Sedbury became the seat of Sir Christopher Boynton when he married Agnes, the heir of Thomas Clarell. After the death of Sir Henry, the last of the Boyntons, the estate passed to the Gascoignes. Around 1611 it came to Sir Marmaduke Wyvill when he married the daughter of Sir William Gascoigne. The estate next passed to the Darcys on the marriage of James Darcy of Hornby Castle, fourth son of Lord Conyers, to Isabel Wyvill in the early seventeenth century.

On his restoration in 1660, Charles II appointed James to be Manager of the Royal Stud. His son, James Lord Darcy of Navan (d. 1733), left the estate to his cousin, whose daughter married Sir Robert Hildyard of Winestead. Sir Robert's son, Sir Robert Darcy Hildyard, made Sedbury his main residence. On the second Sir Robert's death in 1814, the estate passed to James Darcy Hutton, who sold it in 1826 to John Gilpin, vicar of Stockton. The last of his line to occupy old Sedbury was Gilpin's grandson, who died in 1914 after stumbling in a rabbit hole.

In 1919 Sedbury was bought by G. E. Sisterson, who restored and extended the house by one bay while largely retaining the original windows. After his financial collapse in 1925, the estate was offered for sale for £12,000; two years later it was still unsold and listed for £4,000. As a result, the fittings were sold and the house was demolished. A new house was built later. Since 1947 Sedbury has been the seat of the Baker-Baker family, formerly of Elemore and Crook Halls, Lanchester, County Durham. Seated at Crook since the 1630s, George Baker (the customary name for the head of the family) inherited Elemore in the eighteenth century.

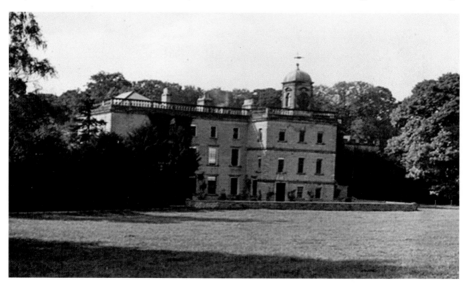

Sedbury Hall.

The Elemore estate passed from George Baker to George Baker until the male line died out in 1837, leaving Isabella Baker as heir. On her marriage to a Baker cousin, the family assumed the double surname of Baker-Baker.

Architecturally, the original Sedbury was a complex house. There was an older Gothic range, including what looked like a pele tower, connected at right angles by older building to an eighteenth-century addition of brick with stone dressings, balustraded parapets and a projection topped by a domed lantern. The later wing had three storeys, although the fenestration of the end of the wing rather oddly indicated only two. The dining room at Sedbury was by John Carr of around 1770. In the 1790s John Foss of Richmond heightened the medieval wing and altered its windows and in the nineteenth century a one-storey Gothic wing was added in front of it. The stables, also probably by Foss, survive.

Slingsby Castle

Slingsby was a 'prodigy house' designed by John Smithson for Sir Charles Cavendish (a dwarf) and dates from the 1620s. Cavendish died in 1653 and Slingsby passed to the Duke of Newcastle then the Duke of Buckingham. Unoccupied, it fell into ruins. The house, which consists of a central rectangular block with a tower at each corner, was bought by the Earl of Carlisle in 1751 and remains part of the Castle Howard estate.

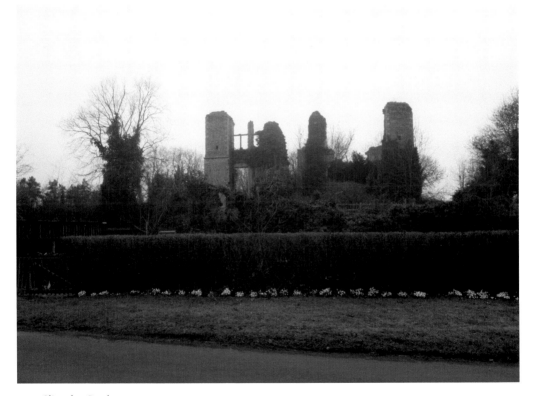

Slingsby Castle.

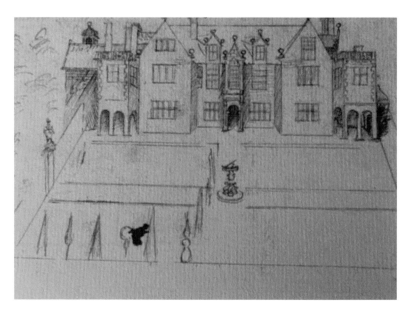

Stainsby
Hall.

Stainsby Hall, Middlesbrough

For several centuries Stainsby was the seat of the Gower family before it
passed to the Turners of Kirkleatham. John Turner was the owner in 1720 and
later owners included the Lascelles family. Stainsby, which was a distinguished
symmetrical house of the seventeenth century with a central porch in a projecting
bay, symmetrical wings and arcaded pavilions at each end of the façade, was
demolished many years ago. Samuel Buck's sketch appears to be the only surviving
representation.

Stanwick Park, Stanwick

The Catterick family first held the manor of Stanwick in the reign of Richard II
(1377–99). Their old seat is now called Kirkbridge House and Stanwick Church
contains a memorial to Elizabeth Catterick (d. 1591), whose great-niece married
Hugh Smithson, who bought the estate in 1638. Smithson was created baronet
in 1660 and built the original Stanwick Park to celebrate his newfound status.
Stanwick came to the Percy Dukes of Northumberland after the marriage of
Sir Hugh Smithson, 4th Baronet, to the Percy heiress, Lady Elizabeth Seymour.
Lady Elizabeth was the daughter of the 7th Duke of Somerset, who was also
Earl of Northumberland, and Sir Hugh was subsequently created Duke of
Northumberland.

 Stanwick Hall, which was built around a central courtyard, was essentially
a seventeenth-century house that was massively remodelled around 1740.
A rainwater head on the south front bore the date 1662 (two years after the
baronetcy). The architect of the remodelling is not known, although Daniel Garrett
(who worked at neighbouring Forcett), Sir Thomas Robinson of nearby Rokeby
and William Kent have all been suggested, of whom the latter is considered to be
the most likely.

The parapet of the west front of the hall had unusual triple-broken parapets, a device used elsewhere by Kent, and the ground-floor windows had rusticated surrounds. The south front was more conventional, with a single parapet over a slightly projecting three-bay centre and two bays on either side. The ceiling of the dining room on the west front had heavy console brackets, features again suggestive of Kent. There was fine plasterwork in the saloon also, with busts in niches and rococo detailing.

In the nineteenth century Stanwick was the home of Lord Prudhoe (d. 1865), second son of the 2nd Duke of Northumberland, and after 1847 the 4th Duke. He commissioned Decimus Burton to add an east wing (lower than the main house) and to remodel the servants' quarters and stables. Suggestions for more radical alterations, including a porticoed entrance and processional corridor, were not carried out.

The 4th Duke's widow, Duchess Eleanor, lived on at Stanwick until her death in 1911, laying out walled and Italian gardens to the design of Nesfield. On her death the best of the contents were transferred to Alnwick Castle and the house was intermittently occupied by the family and by tenants, the last being Colonel Percy.

The estate was sold in the early 1920s to T. Place of Northallerton for £25,500 and the house was demolished in 1923. One room is in the Minneapolis Institute of Arts. The stables and some of the service buildings survive.

A monumental column, erected to mark the Treaty of Aachen of 1748, is now in the garden of Edleston House, Gainford, which also contains an eighteenth-century summerhouse, probably from Stanwick. A rusticated doorway and window pediments from Stanwick are believed to have been moved to the Montalbo Rooms in Gainford.

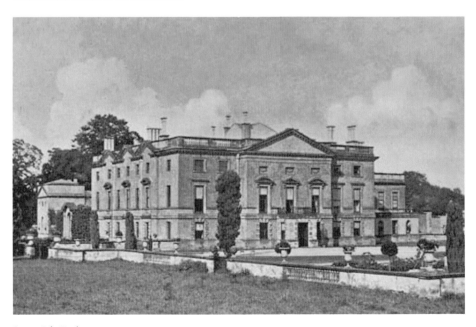

Stanwick Park.

The nearby church was restored by Salvin for Eleanor, Duchess of Northumberland, in 1868 and contains a fine memorial to the first Smithson baronet and his wife. Much of the former Stanwick estate lies within the vast earthworks of a Brigantian town of 850 acres, which was a centre of resistance to Roman rule in the first century BC. Stanwick is believed to originate from the ancient British 'Stane Wegs' or 'Stone Ways', referring to two nearby Roman roads.

Stillington Hall, Stillington

The Stillington estate was bought by Christopher (later Sir Christopher) Croft, Lord Mayor of York, in 1649. It remained in the Croft family, famous as port shippers, until 1895. Sir Christopher probably built a new house on the site of an earlier building, possibly incorporating the original staircase.

At the age of twenty-one, Stephen Croft (1712–98) inherited the estate. He rebuilt the house in brick in the Palladian style, with a main block of two and a half storeys and seven bays, and with a three-bay pediment. Although conventional exteriorly, the first-floor windows under the pediment were no more than pointed lunettes internally, lighting the entrance hall, which had a fine ceiling with octagonal coving.

Two generations later, in 1853, Stillington was inherited by Stephen Croft, who drowned at Balaclava in 1854. Stephen's younger brother Henry inherited the estate and between 1855 and 1859 rendered the house and added an Italianate porch and a conservatory. The staircase hall was also remodelled.

Harry Croft, who inherited in 1871, was the last Croft to live at Stillington. The estate was put up for sale in 1888, but the hall and 662 acres failed to sell. In 1895, the hall and remainder of the estate was sold to Mr Rawdon Thornton, who sold it in 1903 to Mr Matthew Riddell. In the 1930s the house became a retirement home and later a Catholic school. It then entered a period of prolonged decline before its eventual demolition. The Parkfield housing estate now stands on the site. Many of the fittings were salvaged and reused elsewhere. The library fireplace is now in Marston Hall, Grantham.

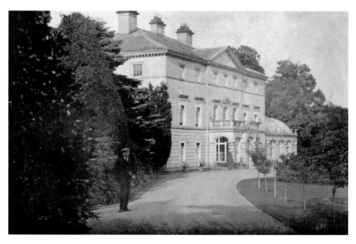

Stillington Hall.

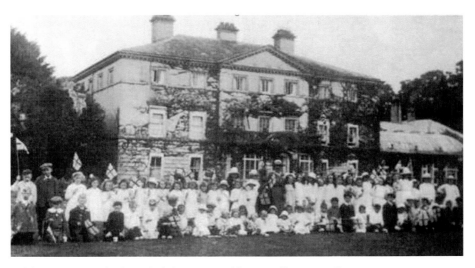

Celebrations to mark the end of the First World War, Stillington Hall.

In 1745 Lawrence Sterne became vicar of Stillington. Dining one evening at the hall with his friend Stephen Croft, he gave a reading from his new and unpublished novel *Tristram Shandy*. Angered by lack of attention to his reading, he is said to have thrown the manuscript into the fire. It was fortunately rescued and its publication went on to make Sterne's reputation.

Studley Royal, Ripon

The landscape of Studley Royal survives intact with the ruins of Fountains Abbey, the eighteenth-century water gardens and Fountains Hall. The great house at the core of the estate was destroyed by fire in 1946. It had largely been built by the Aislabie family in the early eighteenth century after their Tudor house was damaged by fire in 1716, and it retained the core of earlier work. The house contained a series of exceptionally fine interiors though with no coherent plan, having been adapted by different generations of owners. Surviving plans suggest multiple stages of development.

Following the fire of 1716, John Aislabie, very shortly Chancellor of the Exchequer and with a greatly increased income, rebuilt the most damaged sections. William Aislaby renovated the chapel, rebuilt the tower and commissioned Daniel Garrett to remodel the house. The hall assumed its final appearance after further alterations and refacing in 1758–65 when Gothic façades were removed and the house was remodelled with classical details. The main residential block was surrounded by extensive service buildings, also now lost. A Roman Catholic chapel was added by the 1st Marquess of Ripon, but closed with his death when the fittings and glass were transferred to St Wilfred's Church in Ripon.

Studley Royal belonged to the le Aleman family before the end of the twelfth century and remained with their descendants for almost 800 years. From the le Alemans, the estate passed through marriage to John le Gras and his daughter Isabel. Isabel's daughter married Sir Richard Tempest and his great-granddaughter

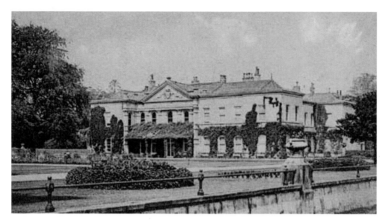

Studley Royal House.

married Sir William Mallorie, whose family owned it until George Aislabie married the Mallory heiress in the mid-seventeenth century.

George Aislabie was a Yorkshire tenant farmer's son who became a clerk and then notary in the ecclesiastical courts in York. Aislabie advanced far in the lucrative legal profession, becoming Receiver General to the archbishop, and inherited substantial estates and money from his master, the recorder of the courts, and from his master's widow. Despite investigation for Royalist activities during the Civil War Aislabie became extremely wealthy, eventually living in the Treasurer's house in York. Marrying Mary Malory, co-heir to Studley Royal, transformed the farmer's son into a substantial country landowner and recognition soon followed with his appointment as Deputy Lord Lieutenant of West Yorkshire. George was killed in a duel at the Treasurer's house in 1675, the precise cause of which has never been established. He appears to have begun the development of the grounds of his new estate, including establishing the avenue and great Studley Gate, which was aligned with distant Ripon Cathedral.

From George, the house passed to his son John, who rose to even greater prominence than his father, becoming Chancellor of the Exchequer. The formal gardens were laid out by John Aislabie between 1720 and 1740, supported by his very considerable income. They occupy the valley by the River Skell, terminated at one end by the abbey ruins and Fountains Hall and at the other by a lake with twin classical fishing pavilions.

Colen Campbell's Banqueting House dates from 1729, providing a pavilion for supper and the enjoyment of carefully contrived vistas. The Temple of Piety overlooks the formal water gardens, the Octagon Tower is approached by a tunnel, and the Gothic Anne Boleyn's Seat provides views along the steeply wooded valley. These gardens were to provide a focus for Aislabie's enthusiasms after his dramatic fall from grace following the collapse of the South Sea Bubble in 1721 when he was found guilty by the House of Commons of 'the most dangerous and infamous corruptions'. A substantial fine followed, but it seems to have had little effect on the Aislabie fortune.

Chancellor Aislabie also significantly enlarged the estate, exchanging substantial areas of land with the Archbishop of York in order to allow expansion of his gardening schemes.

The estate passed from the Chancellor to his son William, who added the Fountains Abbey estate to the Studley estate in 1767, cleared and stabilised the abbey ruins and incorporated them into his designed landscape. The property then passed to William's elder daughter, who died in 1808, and to the daughter of his younger daughter, who died in 1845 leaving the estate to a distant cousin, Thomas Phillip Robinson, 3rd Baron Grantham. Lord Grantham had already inherited Newby Hall from another cousin, William Weddell. In 1833 Grantham had become Earl de Grey on the death of his aunt.

On the death of Grantham in 1859, Studley passed to his nephew George, 2nd Earl of Ripon, who was created Marquess of Ripon in 1871 (his father, the 1st Earl, had, as Viscount Goderich, been prime minister between 1827 and 1828). Newby went to Grantham's daughter Mary, who married Robert Vyner. In 1851 Mary's daughter Henrietta married her cousin, the future marquess. Following the murder by Greek brigands of Frederick Vyner, brother of Henrietta and son of Mary, two churches were commissioned from William Burgess. One, at Skelton, on the Newby estate, was built as a memorial and dedicated to Christ the Consoler; the other, at Fountains, was dedicated to the Virgin Mary. Burgess was also responsible for the Choir School, later used as estate offices and now a National Trust holiday cottage.

Henrietta, Marchioness of Ripon, died in 1907. Lord Ripon died two years later. On the death of their son, the 2nd and last marquess, in 1923, the Studley estate passed to the Vyner family, being purchased by Commander Clare Vyner, son of a cousin of the last marquess, for a rumoured figure in excess of a quarter of a million pounds. During the Second World War, Studley Royal House was occupied by Queen Ethelburga's College for Girls. The nucleus of the 21,000-acre estate was purchased from the Vyners by the West Riding County Council in 1966. The estate is now managed by the National Trust.

After the 1945 fire, the stables by Colen Campbell (1716–20) with their striking arcade, were converted into a house in 1947 for the Vyner family. Salvaged fittings from the earlier house were incorporated where possible. The new house has since been sold. The Studley Royal gardens and Fountains Abbey ruins are now recognised as a World Heritage Site. When visiting in 1795, John Carr's niece, Harriet Clark, refers to Henry Jenkins. He had lived 100 years earlier, dying at the age of 169, and was fond of reminiscing about Fountains Abbey in the days before the Dissolution.

Tanfield Hall, West Tanfield
Tanfield was a secondary estate of the Bruces, Marquesses of Aylesbury, whose principal seat was Tottenham, Wiltshire. In 1819 Sir William Chambers produced designs for a casino for Lord Bruce, although it was not ultimately built. John Carr carried out repairs and improvements to an older house in 1765. Tanfield was demolished in 1816.

Tang Hall, York
There are records of a Tang Hall from the thirteenth century onwards. The name may derive from the 'tong' or junction of two nearby streams. The hall was originally the manor of the Starkey family, however the house demolished in the

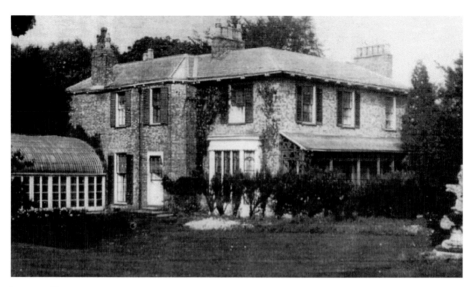

Tang Hall.

1920s was a villa of around 1830 built for James Barber. It was briefly a pub before its demolition. The estate has since been built over.

Thirkleby Hall, Thirsk

Old Thirkleby Hall, of which nothing remains, probably dated from the late sixteenth or early seventeenth centuries. It was completely replaced by James Wyatt's 1775 house, designed for Sir Thomas Frankland. Wyatt's mansion was a distinguished building with a broad bow on the south front and flanking tripartite windows with fan devices in blank arches. The west front had a Corinthian arch superimposed on it with a giant pilasters and arched windows at ground-floor level on each side. The entrance (to the north) was more conventional with a classical projecting porch. At some later point a lower rendered wing was added.

Thirkleby was the seat of the Franklands from 1576 until they sold it shortly before the house was demolished in 1927. For 200 years, the Franklands were effectively hereditary MPs for Thirsk. Sir Thomas Frankland, the builder of the new house, died in 1831 and his son Robert took the name Frankland-Russell upon inheriting Chequers (today the prime minister's official country residence) and a considerable fortune in 1837. He left Thirkleby to his widow, who transformed her Tractarian beliefs into stone to the designs of E. B. Lamb, rebuilding the parish church, a school and other estate buildings. She in turn bequeathed the estate it to her daughter Emily, who married Sir William Payne Gallwey and died in 1913. Their eldest son, Sir Ralph, was an expert on the crossbow. Following the death of his son in the First World War, the estate was sold in 1919 and the house demolished in 1927.

The stables, with an open two-stage tower and the West Lodge and gateway by Wyatt, survive. Wyatt's frontispiece with columns in antis was apparently sold to a buyer in the USA, but its whereabouts have never been established. The site of the house is now a caravan park.

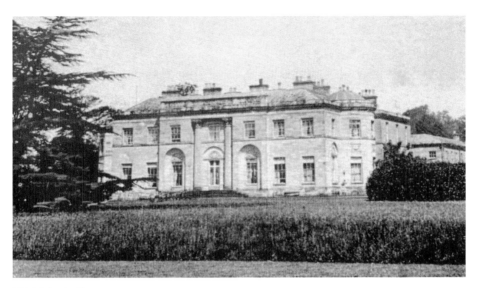

Thirkleby Hall.

The parish church contains a memorial by Flaxman to the three children of Sir Thomas Frankland, as well as glass designed by Lady Frankland.

Thornton Hall, Stainton in Cleveland

A subsidiary seat of the Pennymans of Ormesby, Thornton Hall was demolished in the eighteenth century to pay the gambling debts of 'wicked Sir Jimmy' Pennyman. Thornton was a H-shaped house with decorative pilasters on the wings. The brick wall that surrounded the hall's forecourt survives and a modern house has been built on its site. Two sets of gate piers from the hall stand at the entrances to the nearby churchyard and the church contains a series of Pennyman monuments. Elements of the hall were incorporated into a nearby farmhouse.

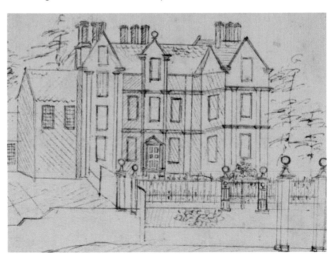

Thornton Hall.

Tocketts Hall, Guisborough

Tocketts Hall (Plantation House) was the seat of the Tocketts from Norman times until George Tockett sold it to the Chaloners of Guisborough in 1715. Through the marriage of Mary Chaloner it passed to General George Hale (1728–1806), who fought with Wolfe at Quebec. The estate was repurchased by Robert Chaloner in 1809 but the hall was demolished in 1815 and the stone used in the building of Guisborough Town Hall.

Tollesby Hall, Middlesbrough

There was a hall at Tollesby (Tollesbi in the Domesday Book) from the sixteenth or seventeenth century until it was demolished in 1984 for housing development. For many years a seat of the Foster family, the hall appears to have fallen into disrepair in the eighteenth century. In 1803 Lord Lonsdale sold the estate to Bartholomew Rudd, whose seat was at Marton Hall. Rudd built a new house a short distance from the old one between 1808 and 1810, to which he moved after Marton Hall burnt down. Rudd's house had five bays with a three-bay pediment, a recessed entrance porch and a balustraded parapet.

For much of the nineteenth century Tollesby was the seat of Bartholomew Rudd and then his grandson, Major John Rudd, who inherited the estate as a minor. Until he came of age the estate was managed by trustees and tenanted. On coming of age, Rudd made many alterations to his own designs, extending the house to one side by two bays, adding a tower and building an

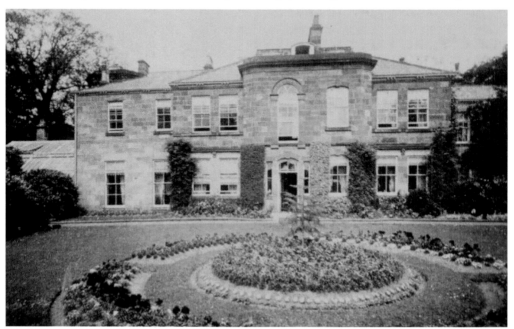

Tollesby Hall.

asymmetrical projection onto the garden front with an off-centre doorway and an arched window at first-floor level. Since Rudd was unmarried and without an heir, in 1886 the house was sold to James Emerson of Easby Hall, from whom it descended to his son Eleazer Emerson. After a period as a builders' yard, the house was demolished and replaced by a housing estate. A ghostly female figure carrying a basket over her arm, believed from her dress to have been a kitchen maid, has been seen on a number of occasions at Tollesby.

Toulston Hall, Tadcaster

Toulston Hall, built in 1603 by Sir Thomas Fairfax, was a seat of the Fairfax family from the sixteenth century until it was sold to Sir Robert Barwick in the mid-seventeenth century. A later marriage between the Barwick heiress and Henry Fairfax brought the estate back to the Fairfaxs. Around 1775 the estate was sold by George William Fairfax, becoming the property of Peregrine Wentworth, a racehorse trainer. After a period as an inn, the estate was sold in 1817. The hall appears to have been demolished sometime before this, as nearby Toulston Lodge was described at this time as 'the Mansion House'. Only earthworks survive to mark the site of the hall.

Upleatham Hall, Guisborough

Demolished in 1897, Upleatham was a seat of the Dundas earls and marquesses of Zetland. The estate was purchased by Sir Lawrence Dundas in the 1760s from money largely accumulated as a government contractor during the Seven Years' War (1756–63).

 Very little is known about the architectural history of the hall, although it was originally built in the seventeenth or early eighteenth century. During Sir Lawrence's lifetime, Upleatham was occupied by his son Sir Thomas, later

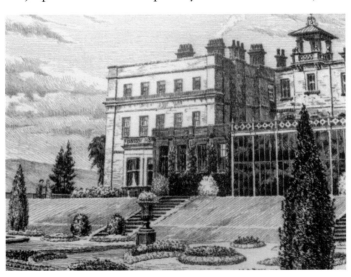

Upleatham Hall.

1st Baron Dundas (1741–1820), who commissioned John Carr to enlarge the house. Lord Dundas' son (1766–1839) was created 1st Earl of Zetland and married a daughter of General John Hale of Tocketts Hall. Zetland made further additions to Upleatham to the designs of Sir Robert Smirke around 1810 and to those of Ignatius Bonomi in the 1840s. His son Thomas, 2nd Earl of Zetland 1795–1873), carried out a further programme of additions, including an Italianate bell tower. Perhaps not surprisingly given its piecemeal development, the hall in its final form was a rather unsatisfactory amorphous composition, although its gardens, largely in the Italian style, were attractive.

Towards the end of the nineteenth century the hall began to collapse as a result of nearby ironstone mining. It was demolished in 1897. Only the ha-ha of the park and walls of the kitchen garden survive. By the early twentieth century, more than half the nearby village had been lost to subsidence.

The old church of St Andrew at Upleatham is often said to be the smallest parish church in England. In fact, it is all that remains of a once much larger building. The new parish church that replaced it is by Bonomi (1835).

Upsall Castle, Upsall

The Upsall estate, which contains the ruins of the ancient castle of the Scropes, was bought by Dr John Turton, Physician in Ordinary to the King, in 1773. The castle, probably begun in 1327 by Geoffrey Scrope, was reputedly demolished in the Civil War. Captain Edmund Turton inherited the estate in 1857 and began a programme of improving the estate buildings to the designs of George Goldie. In the early 1870s, Turton commissioned a new house on the site of the ancient castle. The architects were Goldie and Child and the house was built in 1872–73. During building, the High Gothic design was somewhat toned down; in particular, the tower lost its planned chateau-style roof and was lower than originally intended, and a large conservatory was omitted.

The house caught fire one Sunday in 1918 and by the time the fire brigade arrived (after difficulty catching the horse needed to pull their engine), very little was left. Edmund Turton, Conservative MP for Thirsk and Malton in 1915–29, was created baronet in 1926. His son and heir, also Edmund, had been killed by a sniper on the Western Front in 1915. The house lay in ruins until 1924 when a new house was built in front of the old building and incorporating the surviving fragment of it. Fittings from Wood End were also used in the new building, which remains the seat of the Turton family.

West Bank Park, York

West Bank was built for James Backhouse, a world-famous Victorian nurseryman and plant collector. His nurseries, once known as the 'Kew of the North', stood nearby. Backhouse was also a missionary and was the first to introduce Quakerism to Australia. In 1831 he visited every Australian penal colony in an attempt to improve prisoners' living conditions. West Bank House was a plain house with a centre and gabled wings. It was bought by Sir James Hamilton in 1910 and was later a home for unmarried mothers. It was demolished in the 1970s. Our Lady Queen of Martyrs RC Church stands on the site.

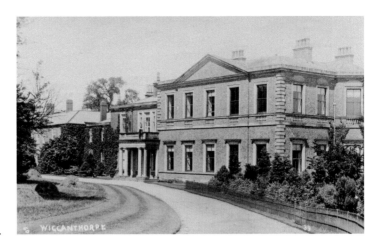

Wiganthorpe Hall.

Wiganthorpe Hall, Wiganthorpe

Wiganthorpe is a lost village in the Howardian Hills. In the early fourteenth century the lord of the manor was Sir Miles Stapleton. After the Stapletons, the estate passed first to the Methams, who rebuilt the hall in the seventeenth century, then to the Geldarts, who bought it in the 1660s and owned it until the 1780s when it was bought by William Garforth. The Garforths were originally from Garforth Hall, Ryton, now also demolished, and William commissioned a new house from the ubiquitous John Carr. Carr added a five-by-seven bay block in red brick to the original house, converting the old hall into a service wing. Carr's house had a two-storey bay in the centre of the longer front and contained outstanding plasterwork as well as a superb staircase.

The estate was inherited by William Garforth's nephew, Commander William Garforth RN, who was a noted bloodstock dealer. The commander's grandson was the last Garforth to own the estate, which was sold in 1890 to William Henry Wentworth, who was engaged to the Earl Fitzwilliam's daughter. The Wentworth-Fitzwilliams carried out some alterations to the house, but the estate was sold again in 1920 after the death of William Wentworth-Fitzwilliam. The new owner was Lord Holden of Alston, who sold the estate in 1937 after which it was split up. Bought by a speculator in 1953, the house was sold for demolition. Many of the interior features were salvaged, including the staircase, which is now at Sharrow Hall, near Ripon. The kitchen wing and stables survive.

Wood End, Thornton-le-Street

Wood End seems to have had a remarkable number of names. Over the years it has been known variously, and in chronological order, as Woodhall, Wood End and Thornton-le-Street Hall, while locally it was known as Gaultby. John Talbot began living at the old hall on a different site in 1549, but the family moved to a house on the Wood End site sometime later. The last of the Talbot line to own the estate, Roger Talbot (d. 1778), carried out major works at Wood End, including the insertion of fine plasterwork. Descriptions of the house at this time mention a long gallery, suggesting that it incorporated the remains of an earlier mansion.

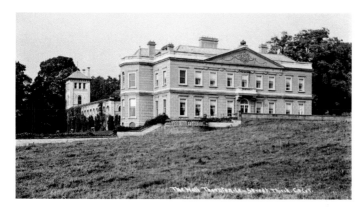

Wood End.

Talbot's heirs sold the estate in 1793 to Samuel Crompton, banker and mayor of Derby, who altered the house around 1800. The resulting house had a nine-bay façade with a pediment containing a cartouche over the middle three. Samuel's son (also Samuel) was created a baronet in 1838. Upon his death ten years later his eldest daughter, Elizabeth Mary, inherited the estate. In 1850 Elizabeth Mary married Lord Greenock, who succeeded as 3rd Earl Cathcart in 1859. In 1884 the house was again remodelled; clad in stone, much of the classical detailing of 1800 was lost. The 4th Earl succeeded in 1905 and after his death in 1911 the house was let. In the early 1920s the estate was sold to a business consortium and the house dismantled. The stables (now a stud) and classical gate lodges survive. One pair of lodges has swags and a Venetian window, a second pair has an arch and columns. The back stairs from the hall were removed to Fountains Hall where they form the main stair.

York Deanery, York
In 1831 the deanery in which Charles I convened a Great Council of the Realm was demolished and replaced by a Gothic building by J. P. Pritchett. The original building had multiple gables and mullioned and transomed windows and presumably dated from the sixteenth century. Its replacement was square with a prominent porte-cochere, corner turrets and oriel windows. It was demolished in 1937 and replaced by the present building by the architects Rutherford and Syme.

The 1831 Deanery.

East Yorkshire

Albion House, Beverley
Albion House was built around 1870 for Josiah Crathorne, a local corn merchant. It was later home to John Barker. Various uses followed, including as a home for female alcoholics, a builders' merchant and a tyre depot. The house, which had prominent Dutch gables, was demolished in 1985.

Anlaby Mansion, Anlaby
The newly built Anlaby Mansion was bought by John Wilkinson in 1738. The mansion was brick with stone dressings, three storeys and seven bays, the middle three breaking forward slightly under a pediment. Wilkinson's widow Katherine sold it in 1771 to Thomas Stack, Hull collector of excise. The house was later owned by a series of merchants and was enlarged and altered at various times. In 1900, the owner was the shipowner Walter S. Bailey and in 1929 it was Mrs Hall Sissons. The mansion was demolished soon after.

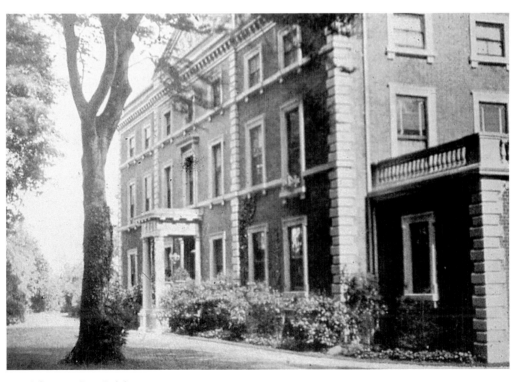

The Mansion, Anlaby.

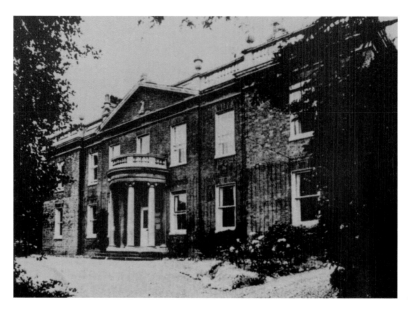

Aston Hall.

Aston Hall, North Ferriby (formerly The Mount)
William Wilberforce, grandfather of the anti-slavery campaigner, bought The Mount in the 1740s, probably modifying the original house on the site rather than building anew. In the later eighteenth century the house was let before being sold to the Hull merchant Samuel Hall in 1792. Hall either added to the original house or rebuilt it completely in the 1830s. The Mount passed to Hall's son-in-law Gardiner Eggington and then to his grandson Samuel Hall Eggington.

In 1871 The Mount was bought by Sir Frederick Clifford-Constable of Burton Constable and renamed Aston Hall. In 1894 the house was purchased by the Turners of Ferriby House and became part of that estate. In 1904 the house was sold to the 1st Lord Nunburnholme, on whose death the estate was sold. Aston was demolished in 1970.

Barmston Manor House (Old Hall), Barmston
The moat, fishponds and fragments of the building remain of the manor house of the Boyntons. Old Hall Farm now stands on the site. The site was occupied from at least the mid-thirteenth century, but the original house was largely dismantled in the eighteenth century. There is a painting of the Old Hall in the early 1760s in the Burton Agnes Collection.

Bellefield House, Sutton-on-Hull
Bellefield was originally built around 1815 by John Hipsley, a Hull draper. Towards the end of the nineteenth century its then owner, Hull businessman Benjamin Pickering, added a tower with an octagonal turret, huge conservatory and billiard room. At the same time the dining room, which contained portraits of every British monarch from William I to Victoria, was panelled. Bellefield House was demolished in the 1960s.

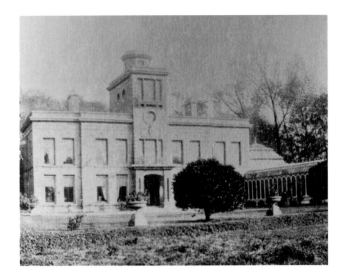

Bellefield House.

Beverley Parks, Beverley

Beverley Parks was once a medieval deer park belonging to the archbishops of York and came to the Wartons in 1628 when Sir Michael Warton bought it from the Crown. The Wartons presumably initially occupied the archbishop's hunting lodge and would dominate Beverley for a century as landowners and Members of Parliament.

Towards the end of the seventeenth century a later Michael Warton built a new house (illustrated by Samuel Buck around 1720). On Warton's death in 1725, the estate passed to the families of his three sisters. It was eventually divided in 1775 when the properties in and around Beverley passed to Charles Anderson Pelham, later 1st Earl of Yarborough, who demolished the Beverley Parks house. The Pelham estate was broken up in the early nineteenth century and Beverley Parks became part of the estate of the Bainton family in 1834. The Bainton estate was broken up in the first half of the twentieth century. A fragment of the house survives as part of a farmhouse.

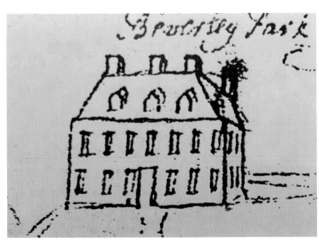

Beverley Parks.

Bishop Burton (High) Hall, Bishop Burton

Today's agricultural college at Bishop Burton stands on the site of three lost houses. The first, now long gone, was the medieval palace of the archbishops of York. The ditch and bank which surrounds the college grounds marks the boundary of the ancient deer park of the archbishops.

The second house was built in the early seventeenth century by William Gee, recorder of Hull and Beverley and secretary of the Council of the North, who had purchased the estate in 1603. Gee's father, William Sr (d. 1600) was a Merchant of the Staple and benefactor, donating £80 and 20,000 bricks to build Hull Grammar School, founding a hospital for ten poor women and giving the town a gold chain to be worn by its mayoresses.

The house was significantly altered by William Gee, who owned the estate from 1678 to 1718. William Gee had two sons: Thomas, who lived at High Hall after his father's death, and James, who lived at the lost Low Hall. This house remained the residence of the Gee family until the last of the male line, Roger, died in 1778.

In 1783, the Bishop Burton estate was purchased by Richard Watt, a Liverpool merchant with a fortune from West Indian sugar who had started as a coach driver and later bought Speke Hall. The Watts made Low Hall their home, but in 1790 High Hall was gutted by fire. After repairs the house was divided into tenements, but it was demolished by Francis Watt before his death in 1870.

William Watt commissioned George Devey to design a new house in a vaguely Tudor style, which was built from 1871. Unfinished and unoccupied after William's death in 1874, Devey's house was completed by W. H. Fletcher of London in 1886 for Ernest Hall-Watt, whose home it became. William Broderick Thomas was commissioned to lay out the grounds.

Richard Hall-Watt, squire of Bishop Burton, was killed in action in 1916. In 1930 the majority of the estate was sold to O. S. Hellyer, and in 1951 East Riding County Council bought the hall and two farms for use as an agricultural college. The mansion was demolished and replaced by new buildings. Fletcher's stable block and lodge and the walled garden survive.

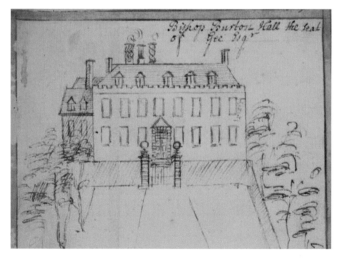

The second Bishop Burton Hall.

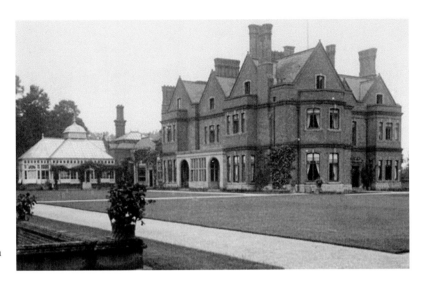

The third
Bishop Burton
Hall.

Bishop Burton Low Hall, Bishop Burton

Low Hall was built in the second quarter of the eighteenth century and demolished
soon after 1874. A design for the house by Lord Burlington is in the RIBA
Collection. Low Hall was once a home of the Gees of High Hall, Bishop Burton,
and later of the merchant Richard Watt.

Brough House, Brough

Brough House was an Italianate mansion built in 1850–52 by T. W. Palmer,
mayor of Hull in 1850–51. The house was later the home of Sir J. T. Woodhouse,
also mayor of Hull, who substantially altered it. Brough House was demolished
around 1960.

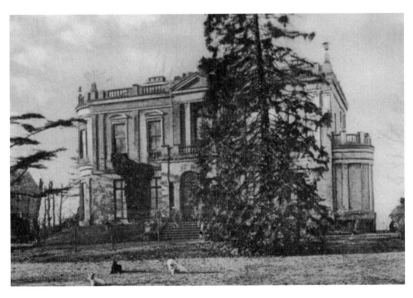

Brough House.

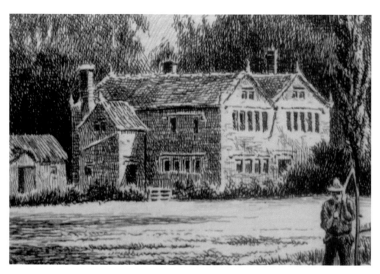

Burstwick Hall.

Burstwick Hall, Burstwick

Earl Tosti, who died at Stamford Bridge in 1066, was Lord of Burstwick before the Norman Conquest. During the fourteenth century Burstwick was one of the most important royal manors in the north of England. It was built around a court and contained great and little halls, two chapels, an outer and inner gatehouse, kitchens, cellars, a buttery, bakery, and brewhouse. Elizabeth de Burgh, Queen of Scots and wife of Robert the Bruce, was imprisoned at Burstwick before being moved to Bisham Abbey Manor, Berkshire, in 1308. The hall was later demolished – probably in the nineteenth century. The remains of a moat, possibly of Burstwick Castle, surround the site of Burstwick Hall.

Camerton Hall, Camerton

The manor of Camerton was bought by Edward Ombler in 1785 and the house was built either by him or his son before 1810. The house was built in red brick

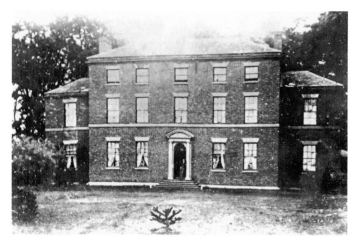

Camerton Hall.

and had five bays and three storeys, with lower wings of one bay and two storeys set back at each side. Camerton Hall was derelict by the late 1940s but was not pulled down until the early 1970s.

Cottingham Castle, Cottingham

Only the name of Castle Hill Hospital, which stands on the site, commemorates the lost nineteenth-century Cottingham Castle. The medieval Cottingham Castle has also vanished without a trace. The nineteenth-century castle was built by the banker Thomas Thompson between 1808 and 1816. The son of a farmer, Thompson entered the banking firm of Wilberforce and Smith as a clerk, rising to become a partner. In 1807, Thompson became an MP.

To satisfy his desire for a suitable residence and provide a change of atmosphere for his consumptive daughter, Thompson bought 54 acres of land in Cottingham in 1800. The foundation stone of the new house was laid in 1808 – the year the stables were built. In 1812, Thompson, a well-known philanthropist, paid unemployed local men to tunnel for chalk under the estate. These tunnels are said to still exist. The house was complete by 1816 and the family moved into the castellated mansion with a tower at each corner, the grandest being octagonal and 40 feet high.

Cottingham Castle was built of white brick with stone dressings, possibly to the designs of Henry Hakewill. Thompson died in Paris in 1828, leaving the estate to his son, Major General Thomas Perronet-Thompson, who chose to rent out the house.

On 2 May 1869, when it was rented by a Hull timber merchant by the name of John Barkworth, the castle was destroyed by fire. The stables and outbuildings survived.

In 1913, Hull Corporation bought the site for use as a hospital and the remaining buildings were demolished. The gateway survived until 1961. All that now remains is a folly, the Belvedere, built in 1825 to allow Thompson's consumptive daughter to take the air.

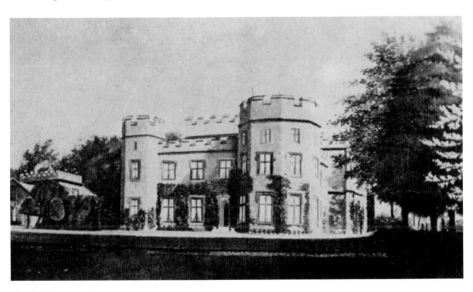

Cottingham Castle.

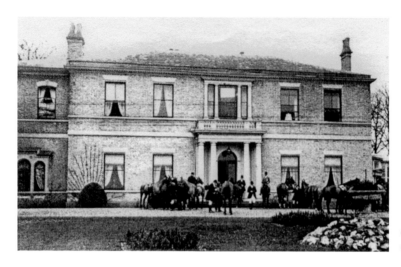

Cottingham
Grange.

Cottingham Grange, Cottingham

Cottingham Grange was built in 1800–02 by the Hull merchant George Knowsley. In the nineteenth century it was the seat of the Ringrose family, prominent in the area since the seventeenth century; various owners followed. During the Second World War the Grange was used as officers' quarters and barracks were built in the grounds. Cottingham Grange was demolished around 1950 to make way for a new secondary school. Cottingham High School now stands on the site.

Cottingham Hall, Cottingham

A late eighteenth-century house built by Hull merchant William Travis, Cottingham Hall remained in the Travis family until the mid-nineteenth century. Bay windows were added to the main façade in the Victorian period. Cottingham Hall was demolished in 1936.

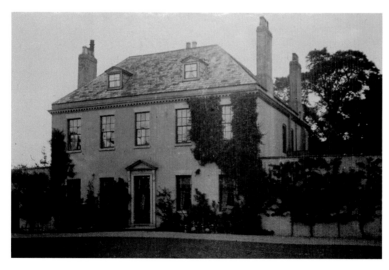

Cottingham
Hall.

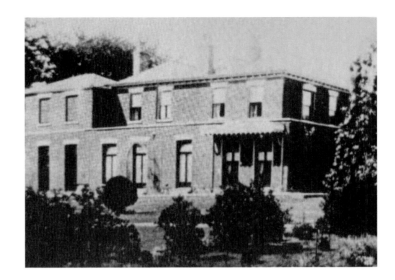

Cottingham
House.

Cottingham House, Cottingham

Cottingham House was demolished in 1972. It started out as the house of
James Mines, a local merchant in the mid-eighteenth century. This was altered
and enlarged in the nineteenth century when it was the home of a series of Hull
merchants.

Dairycoates Lodge, Hull

Dairycoates Lodge was built in 1809 by Antony Atkinson, who owned a nearby
brick and tile factory. At the time it was built Dairycoates was a rural idyll, a

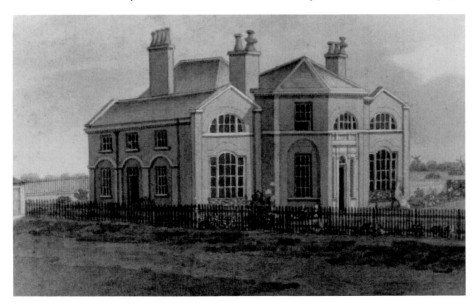

Dairycoates Lodge.

contemporary gazetteer reporting three residents, two of whom (one being Atkinson) were involved in the brick trade and the third was a farmer. The local author Reginald Corlass, of *Sketches of Hull Authors*, was born in the lodge in 1854. Dairycoates Lodge was demolished in the 1870s, the area having fallen victim to the railways and industrialisation.

Easington Hall, Easington

Easington was the seat of the Overton family from the late medieval period until 1720 and was also known as Overton Hall. Thomas de Overton was the first Prior of Haltemprice in Cottingham and another Thomas Overton was a Baron of the Exchequer in 1403. Colonel Robert Overton was the Governor of Hull from 1659 to 1660. The hall was reputedly haunted by a spectre that contaminated any milk or water left out with blood. A letter from the family chaplain, dated 1673, describes the haunting:

> About 17 years agoe I went down Chaplain into Yorkshire to Esqr. Overton of Easington, in Holdernes, upon his having married a Gentlewoman in Leicestershire, of my acquaintance Soon after my coming to his house, I was informed by some of the inhabitants of the town, that his house was haunted against the death of any of the family ... The rooms commonly said to be disturbed were the garret, and three chambers, betwixt which and the family, I lodged. I heard frequently in the night as if a person came up the back stairs into those rooms, and walked up and down the next roome to me, and when it went down stairs it was as if a woman descended, and her coats swept the stairs. An old servant told me they have some seldome times seen the spirit, and that it was in the likenes of a maid of the family whom their old mr. not permitting to marry one she was deeply in love with, she pin'd away and dyed, and that this disturbance in the house had been from her death ... Against the death of the Gentleman's mother, a servant who then lived there, told me that they filling the copper with water overnight in order to brewing, in the morning, it was blood and could not be used, and their milk was spotted with blood severall nights.

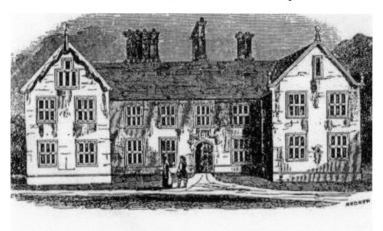

Easington Hall.

The last was also when I lived there: the Gentlewoman calling me one morning to see it I told her surely it must be the cats lapping with bloody tongues. She replied that could not be, since it was further than it was possible for them to reach, and more than it can be supposed a cat's tongue should bleed while lapping; we resolved to see how it would be if closely covered, and the next evening she ordered all the milk to be put into one larg vessel, which with our own hands we closely covered, and locked the door, and she tooke the key up with her to bed. In the morning when she was about to go in, she was pleased to call me, and the milk was as bloody as any time before, and the inside of the vessel the spots were bigger and less, and the largest as broad as a silver twopence.

Having been divided into tenements in the nineteenth century, the house was demolished around 1887.

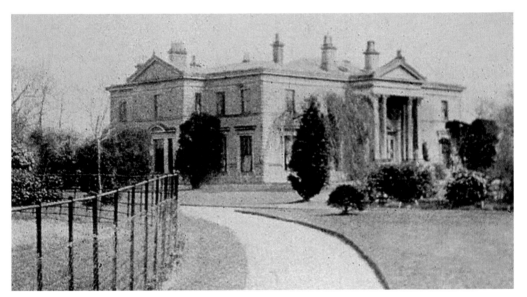

East Ella.

East Ella, Anlaby
East Ella was built for John Galloway, a solicitor, in 1842 and sold to Robert Jameson in 1857. By 1926 it was described as 'definitely worth only the value of the old materials, less the demolition'. East Ella survived until the 1940s, when it was pulled down.

Elmswell Old Hall, Elmswell
Elmswell was probably built around 1635 for Henry Best, who in that year ordered 400,000 bricks from Jon Arlush of Beverley. Best was a noted writer on farming and husbandry. Elmswell Old Hall was derelict by 1993, but the ruins, which are Grade II*, have been consolidated.

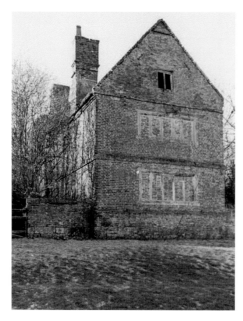

Elmswell Old Hall.

Field House, Anlaby

Field House is believed to have been built in 1849 as a private asylum by the surgeon Francis Casson, possibly incorporating parts of an earlier house. The asylum closed in 1855 and the house became a private residence. After a period of dereliction Field House was demolished in the mid-1960s.

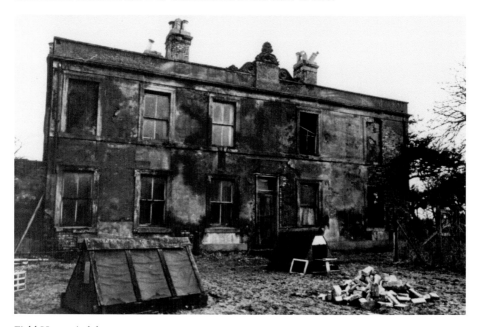

Field House Anlaby.

Foggathorpe Hall, Foggathorpe

The seat of the Aikroyds, Foggathorpe Hall, was demolished in 1743 and a farmhouse built on the site. The original moat survives as a crop mark.

Grimston Hall, North Grimston

Grimston Hall, drawn by Samuel Buck around 1720, probably dated from the early seventeenth century after an earlier house burned down. Only fragments remain of the manor house of the Langley family, lords of the manor from the seventeenth century. The estate passed to the Hutchinsons, who assumed the name Langley. Upon the death in 1824 of Dorothy Langley, it went to the Dawnay family. The Dawnays also assumed the Langley name and in 1851 the property passed to William Dawnay, 7th Viscount Downe. The house had been demolished by no later than 1839. The remains of the moat of Grimston Hall stand near Grimston Garth.

Harpham Hall, Harpham

The buried remains and earthworks of the medieval manor house of the St Quintin family stand near the church at Harpham. Part of the manor of Burton Agnes, Harpham passed from the Stutevilles to the St Quintin family by marriage. It became the principal seat of a branch of the St Quintin family until they moved to Scampston Hall in the seventeenth century. Nearby is Drummer's Well, into which a St Quintin is said to have pushed the drummer boy whose ghost now walks the site.

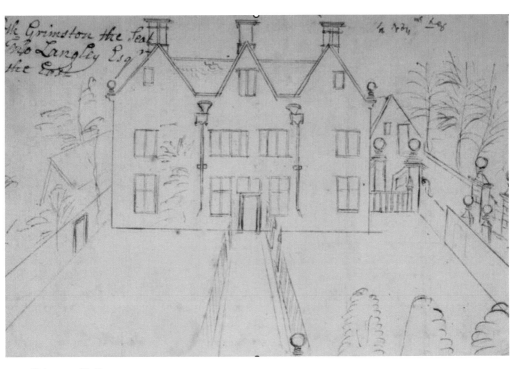

Grimston Hall.

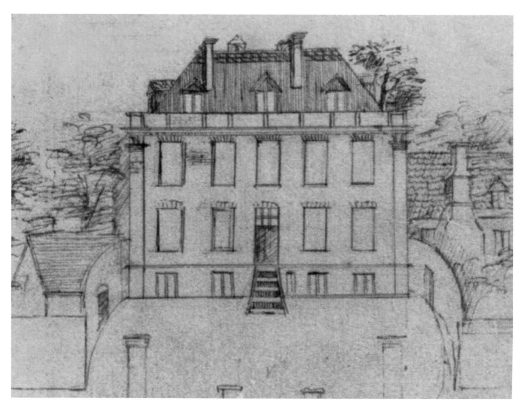

Hayton Hall.

Hayton Hall, Hayton

Hayton was the seat of the Rudstons from at least the fourteenth century until
its demolition. The hall was probably built by Sir Thomas Rudston in the 1660s.
It was drawn by Samuel Buck around 1720. The house was remodelled in the
early eighteenth century and demolished in 1805, its site having been near the
former village school. Some outbuildings survive and a tunnel is said to connect
the church to the site of the manor house. A later member of the family who
retained the estate commissioned plans for a new hall at Hayton in 1887, but this
was never built.

High Paull House (formerly Paull Manor), Paull

In 1769, Benjamin Blaydes, a Hull shipbuilder, bought Paull Manor from William
Constable of Burton Constable. The house he built was called High Paull House
or Manor and was enlarged after 1822. It remained in the Blaydes family until
1853 when it was bought by Anthony Bannister, coal merchant and mayor of
Hull. The house, which adjoined Paull Battery, was bought from Bannister by the
War Department in 1861 and further enlarged in 1900. High Paull House was
demolished in 1920.

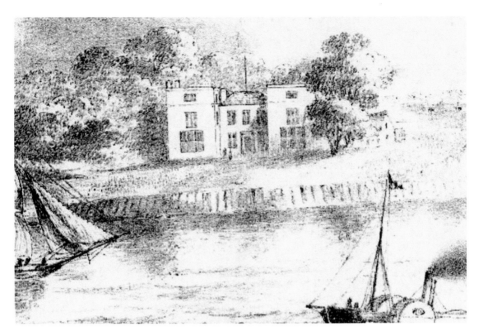

High Paull House.

Hilderthorpe Hall, Bridlington

Hliderthorpe Hall (also known as Flat Top Farm) was built as a seaside villa by the Tattons of Sledmere and has been ascribed to John Carr. The ground and top floors housed the resident farmer and the piano nobile was reserved for the Tattons to enjoy the views across the bay from an octagonal saloon with flanking lodgings.

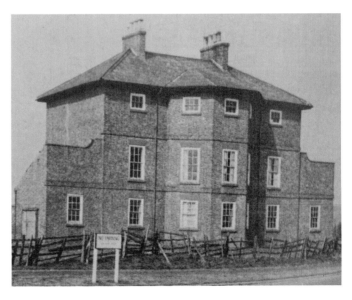

Hlderthorpe Hall.

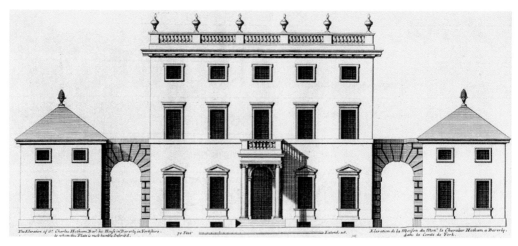

Hotham House, Beverley.

Hotham House, Beverley

Hotham House was an exceptionally distinguished house built by Sir Charles Hotham, 4th Baronet, to the designs of Colen Campbell and was completed in 1721. The main seat of the Hothams had been at Scorborough, which burned down in 1705. Hotham was little used by the family and was sold to Thomas Wrightson in 1766. Wrightson soon demolished the house, but being an enthusiastic property developer, appears to have used various features from it in other buildings around Beverley. An elaborate monogrammed cornice from Hotham House, formerly in the Nag's Head pub, is now in Beverley Art Gallery.

Howden Manor (Bishops' Manor), Howden

Howden Manor, as it now stands, is only the great hall of the manor house of the bishops of Durham. It was built between 1388 and 1405 for Bishop Skirlaugh but incorporated earlier work. The medieval hall was altered in the sixteenth, eighteenth and twentieth centuries. The former great hall has been divided into two floors, with several rooms on each level. The prominent vaulted porch built by Bishop Skirlaugh formerly led to a screens passage, now removed. King John spent Christmas 1211 at Howden Manor and kings Edward II and Henry V also stayed there. Ownership of the manor passed to the Bishop of Ripon in 1837 and to the Church Commissioners in 1857. Howden Manor is now privately owned and is operated as an events centre offering accommodation.

Kilnwick Hall, Kilnwick

The demolition of Kilnwick in 1951–52 was one of the most serious losses of East Yorkshire houses. Kilnwick probably developed from a grange of the nearby Watton Priory. At the Dissolution it was granted to Robert Holgate, who was later Archbishop of York. The estate had a number of owners and by the time Samuel Buck drew it in 1720 it had become a sizeable, mainly Jacobean, house,

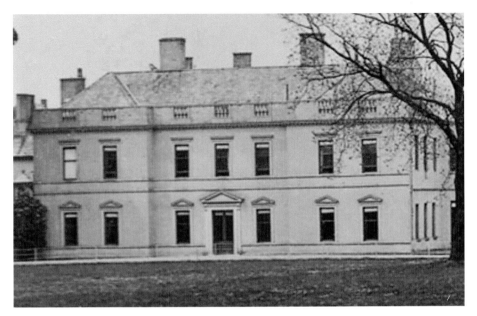

Kilnwick Hall.

the greater part probably built by Roger Thekestone in the late sixteenth century or Nicholas Stringer a decade or two later. In 1722, the estate was purchased by Colonel Thomas Condon, who added a symmetrical front to the south, refaced the remaining part of the old wing and demolished the porch. When Thomas Grimston bought the estate in 1747 on behalf of his relative Admiral Henry Medley, the new house was still unfinished.

Thomas Grimston, his son John and grandson Thomas II all made changes to the house. The York stuccoist Thomas Perritt worked at Kilnwick and Henry Cheere contributed chimney pieces. Between 1769 and 1774 a bay was added to the drawing room and a library was formed from two smaller rooms by John Carr. Further stucco work was carried out by Guiseppe Cortesi.

Kilnwick remained the seat of the Grimstons for 200 years until the twentieth century when, in 1943, on the death of Captain Luttrell Grimston Byrom, it was sold. Little remains of Kilnwick today, only a seventeenth-century block that once formed servants' accommodation to the west of the main block and gate piers by Carr. Some fittings found their way to other houses. Chimney pieces went to Hallgarth, Goodmanham and Reighton halls. There is a Chinese bed at Sledmere and Burton Agnes has doors and wainscoting, which are said to have come via Kilnwick from Leconfield Castle. The staircase was put into store where it was destroyed by fire.

Kingtree House

Kingtree was the home of Samuel Watson, who created extensive and elaborate gardens with an ornamental lake and bridges, described by Arthur Young in 1769: 'at this place Mr. Watson has a pleasure-ground, which is very well worth seeing;

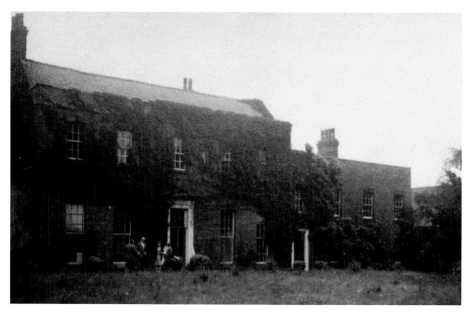

Kingtree House.

it consists of shrubberies with winding walks, and the imitation of a meandering river through the whole...'

After Watson's death, his widow lived at Kingtree House until her death, when it was sold. After having a series of short-term occupants, Kingtree was demolished.

Knedlington Manor, Knedlington

Thomas Clarke, a prominent local landowner built Knedlington Manor in 1841 and 1842. The architects of the Tudor-style new house were Weightman and Hadfield of Sheffield. During the First World War the grounds of the

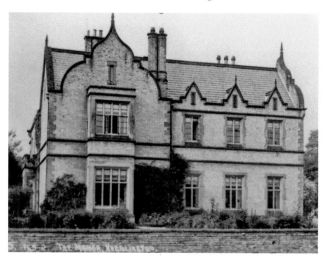

Knedlington Manor.

manor accommodated German prisoners of war. The estate was sold after the death of Thomas Sinclair Clarke, son of the builder. The purchaser was James 'Jimmy' Mortimer, who owned the airship station where the R100 was built. In 1931 Mortimer was host at Knedlington to Dr Hugo Eckener, commander of the Graf Zeppelin. Mortimer later moved to Howden Hall, selling the Knedlington estate to the Earl of Yarborough, from whom it passed to his daughter, Lady Diana Miller. Knedlington Manor was demolished in the 1950s.

Leconfield Castle, Leconfield

Henry de Percy was granted a licence to crenallate his moated manor house in 1308. The castle remained a de Percy residence, except for a period when it was surrendered to Henry VIII (1537–57), until it fell into dereliction prior to its demolition at the beginning of the seventeenth century. In its heyday, Leconfield was a substantial house, standing inside its moat with a tall brick tower at each corner. The house was entered over a drawbridge and through a gatehouse in the middle of one side. Inside there were four ranges around a courtyard. The accommodation for the earl was in twenty-three chambers in the south range.

Henry VIII stayed at Leconfield after its surrender to the Crown, repairing the fabric of the house and enlarging the park. The Percys never lived at Leconfield after it was returned to them. By the 1570s the house was in a state of decay. It was demolished around 1608–09, with many of the fittings removed to Wressle Castle. Traditionally some panelling was subsequently removed from Wressle to Kilnwick and from Kilnwick to Burton Agnes.

Londesborough Hall, Londesborough

When Londesborough Hall, then a seat of the Duke of Devonshire, was demolished in 1818, it was East Yorkshire's grandest house. From 1469 to 1643 Londesborough was the seat of the Cliffords, earls of Cumberland. It was later held by the Boyles, earls of Burlington, to whom it had passed by marriage. In 1753 the estate passed from the 3rd Earl of Burlington to his son-in-law William Cavendish, who later became 4th Duke of Devonshire.

The central three-storey seven-bay block of the house was built by Francis, Lord Clifford, around 1590. In the 1670s, Richard Boyle, 1st Earl of Burlington added a three-by-seven bay two-storey wing to each end of the original building. The architect for these additions is believed to have been Robert Hooke, who probably also designed the stables and surviving almshouses.

The Devonshires took little interest in Londesborough before it was demolished on the orders of the 6th 'bachelor' Duke, who had more than enough other houses and estates including Chatsworth and Hardwick, to which many of the contents were transferred. In 1839 he had a hunting box built on the estate but sold the whole property to George Hudson 'the Railway King' in 1845. A private railway station was built for Hudson's personal use.

Hudson was soon ruined, his fraudulent practices having caught him out, and in 1850 he sold Londesborough to Albert Denison, later Baron Londesborough, who enlarged the hunting box to create a country house.

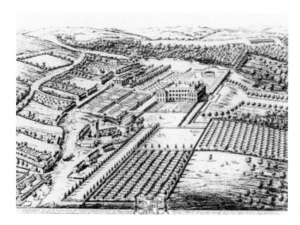

Londesborough Hall.

The park at Londesborough was designed by Richard 3rd Earl of Burlington and his gardener Thomas Knowlton. Its development required the removal of the village of Easthorpe. Between 1728 and 1732, £1,600 was spent transforming the landscape into what was undoubtedly the finest eighteenth-century landscape and garden in the East Riding. The remnants of the tree-lined avenues that radiated form the house and dated from the 1730s, the great lake, the walled kitchen garden with its entrance designed by William Kent, and the terrace wall survive. One avenue originally connected the gardens with the York road a mile away, crossing the Everingham Park estate on the way. The seventeenth-century stable block has been converted to housing.

Melton House, Melton

Melton Hall was built around 1830 by Mrs Ann Wilson. On her death in 1855 it passed to her sister, Mrs Reynolds, and then to Thomas Heathfield. After a period of decline between the two world wars the house was converted into bedsits and finally demolished in 1957. The only known image is of the entrance.

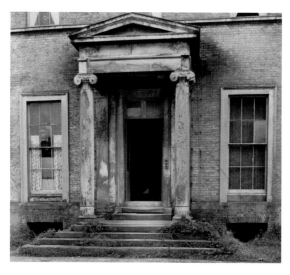

Melton House.

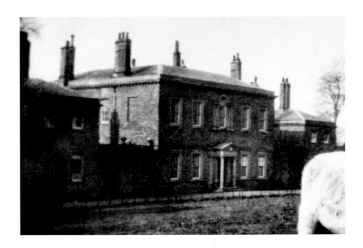

Melton Hill House.

Melton Hill House, Melton

Melton Hill House was built about 1780 by Joseph Williamson, a Hull merchant. The central block had two storeys and five bays, connected by single-storey two-bay links to two-storey two-bay pavilions. The house, which had splendid views over the Humber estuary, was sold in 1822 when it was bought Charles Whittaker, another merchant, who was twice mayor of Hull. After the death of Whittaker's widow the house was bought in 1875 by the Broadley family, who owned it until 1952 when its new owner demolished it.

Neswick Hall, Neswick

Neswick Hall, demolished in 1954, was a vaguely classical house with a central five-bay block and three-bay projecting wings, each under an oversized plain gable. The hall in its final form dated mainly from various periods of the eighteenth and nineteenth centuries. A seat of the Salvin family for 200 years until it was sold

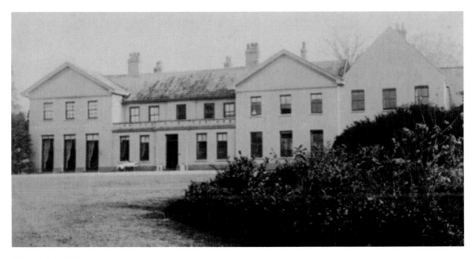

Neswick Hall.

to Thomas Anlaby of Etton in 1613, in around 1710 the property was divided between the daughters of Matthew Anlaby of Lebberston. In 1714 Thomas Eyres, a Hull surgeon and husband of one of the heiresses, purchased the other four shares and became sole owner. One of Eyres' two daughters married Robert Grimston, a Bridlington attorney who purchased the other half of the property. The Grimstons remained at Neswick, although the estate passed by marriage to the Wranghams. They retained it until after the Second World War when most of it was sold, although the family retained the site of the hall and its grounds until the 1980s. The Grimstons descended from Sylvester Grimston, who is said to have attended William I as his standard bearer.

Newington Hall, Hull

Newington was built between 1840 and 1842 by James Hodgson, son of a Hull grocer and became known as 'Bacon Hall' as a reflection of the source of Hodgson's wealth. The house was a fine Greek revival mansion of five bays with a dramatic Corinthian portico crowned by a pediment. The planning was less sophisticated than the elevations; reception rooms on the ground floor lay off the central staircase hall, which rose through the full height of the mansion; upstairs were seven bedrooms. An attached single-storey block contained service rooms. Newington was almost certainly designed by the architect John Buonarotti Papworth.

James Hodgson sold Newington in 1861. The new owner was the then mayor of Hull, William Hodge. The house passed through a number of hands and the last owner was John Watt, who bought it in 1891 and sold it in 1908 when it was demolished.

North Cave Hall, North Cave

A remnant of North Cave Hall may survive in Manor Farm East. The North Cave estate was largely developed by Sir George Metham, whose family had owned the property since the early sixteenth century. Unfortunately, he bankrupted himself building a new seat, Hotham Hall, on the same estate and sold the property to Robert Burton. Either Hotham or his successor demolished North Cave Hall around 1770. Some materials from the hall, including the 1683 date stone, were incorporated into the Hotham stable block. The Metham family retained North Cave, which passed by inheritance to its current owners, the Carvers.

Northfields, Cottingham

Built in 1780 as Northgate House, probably for Edward Thompson, and extended by 1820, Northfields was a stuccoed villa with pilasters and pavilions linked to the main block. The house belonged to George Ringrose in 1825 and to the heirs of John Parker by 1831. It was used as a private asylum from 1825 to 1834 and by 1845 it had passed to Joseph Armstrong, a chemist, who sold it to Benjamin Rayner. Thomas Ringrose bought the house in 1847. Arthur Harrison owned the hall for the remainder of the nineteenth century, adding a wing to the west in 1867.

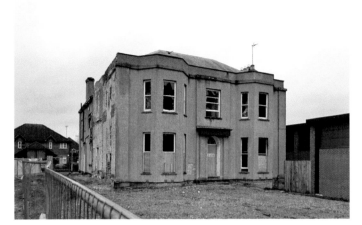

Northfields. The 1867 wing is to the left of the tree and the original building is partly concealed behind it.

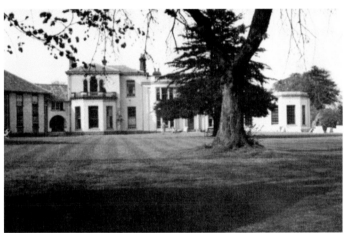

Northfields after demolition of all additions to the original block.

The house was acquired by University College Hull in 1928 and became Needler Hall, a student residence for the college and later for the University of Hull, named after Frederick Needler whose fortune came from sweet manufacture. The hall was massively extended in various stages but closed in 2016 and was largely demolished. Plans for future development include the retention of the original two bay-window-fronted former 1780 wing of Northfields House. The poet Roger McGough lived in Needler Hall for three years from 1955, and Phillip Larkin was at one time sub-warden of the hall.

Oakdene, Cottingham

Oakdene was built before 1816 by the Hull merchant John Hill, who had purchased the 9-acre site in 1810–11. The house passed to Hill's son John, who let it to the Hull Town Clerk, George Codd. In 1890 the house was known as South View, but the name was changed to Oakdene from 1904 during the occupation of William Cook, a local shipbuilder. The house was demolished around 1958 to make way for the Oakdene housing estate.

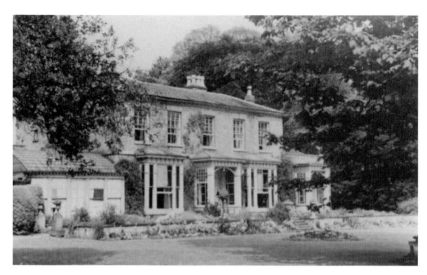

Oakdene.

Ousefleet Hall, Goole

Ousefleet Hall was built in 1873 by the Empson family. The architects were J. B. and William Atkinson and their house was in the French style with Mansard roofs, dormer windows and corner towers capped by elaborate iron railings. The house was unoccupied after the death of Mr R. Cornwall Empson in 1897, its owner James C. L. Empson living elsewhere. After a short interval as a hydropathic establishment, the house and its 3,700 acres were bought from the trustees of Mr R. C. Empson in 1916 by the Co-operative Wholesale Society for use as a potato farm. The hall survived until the 1950s.

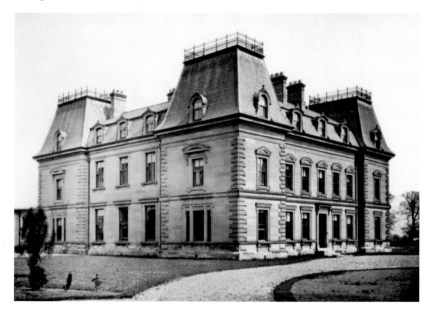

Ousefleet
Hall.

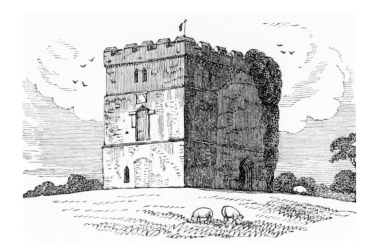

Paull Holme Manor House.

Paull Holme Manor House

Paull Holme was the seat of the Holme family from after the Norman Conquest until the eighteenth century when the estate passed to the Torre family through marriage to the Holme heiress. The manor house was abandoned by the end of the sixteenth century and by 1840 only the north tower, dating from the Tudor period, remained. The tower, which has recently been conserved, has three storeys and is built of brick; its ground and first floors were vaulted in brick. It was restored in 1871 for use as a gazebo before falling once more into decay. A chapel is known to have existed on the site but was ruinous by the early eighteenth century.

Rawcliffe Hall, Goole

Demolished in the 1990s, Rawcliffe Hall was one of Walter Brierley's less satisfying designs. The hall was built by the Creyke family in the 1890s after an earlier hall burnt down. In 1919 the property was sold to the council and opened as a psychiatric hospital in 1921. Rawcliffe Hall was demolished in the 1990s and its former grounds have been covered by housing.

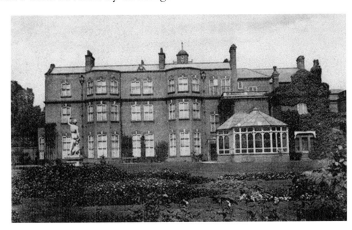

Rawcliffe Hall.

Riccall Hall, Riccall

From 1654 to the mid-nineteenth century Riccall Hall was the seat of the Wormley family. In 1776 the house was said to have previously been called Beckwith's Hall, Newark and Leonard Beckwith having conveyed it to Edward Wormsley. The house was rebuilt by a later Edward Wormley (d. 1787). The estate was bought by Lord Wenlock in 1853 and the house much altered in the 1880s. Riccall Hall was demolished in 1951–52 and the outbuildings converted to form the present Riccall Hall.

Risby Hall, Risby

The Ellerker family held the Risby estate from 1401 to 1655 when the last male heir died. The estate eventually passed by marriage to Sir James Bradshaw, who built a new house on a different site in the 1680s. This house is also lost, although the terraces of its elaborate formal gardens (also laid out by Sir James) survive and the impressions of its cellars remain. A rectangular earthwork near today's Park Farm, known as Cellar Heads, probably marks the site of the earlier house where Sir Thomas Ellerker entertained Henry VIII in 1540.

In 1742, the estate was inherited by Easton Mainwaring Ellerker, who laid out a lake (part of which still survives) and built a Gothic folly. Ellerker died in 1771 and the estate passed to his son Roger, who died only four years later. The heirs were Roger's four sisters.

The second house was destroyed by fire in the late 1770s and subsequently rebuilt. In 1784 the house burned down once more, leaving 'a library, a range of spacious offices, and two lodges'. These remaining buildings were later demolished. The estate was inherited by the Onslow family, who sold it to Charles Wilson, later Lord Nunburnholme. Plans to build a new mansion near the Cellar Heads site were later abandoned after some building had been carried out.

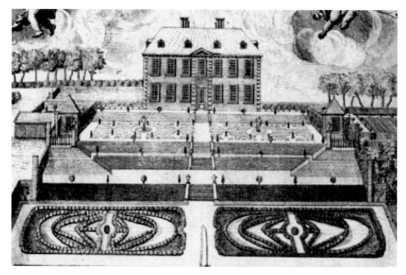

Risby Hall.

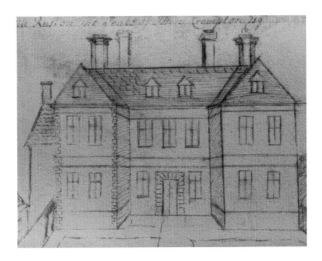

Ruston Parva.

Ruston Parva Hall, Ruston Parva

Ruston Parva Hall was a late seventeenth-century house and was sketched by Samuel Buck around 1720. At that time it was a seat of the Crompton family, who sold it shortly afterwards. The hall was demolished before the mid-nineteenth century.

Scorborough Hall, Scorborough

Scorborough Hall was a seat of the Hothams before they settled at South Dalton. Their early seventeenth-century house, which probably replaced a moated manor house near the church, was destroyed by fire in 1705–06. A farmhouse known as Scorborough Hall was built on the edge of the moated site in the late eighteenth century. The Hothams descend from William de Hotham (*c.* 1100–66) and are still seated at South Dalton. Sir John Hotham and his eldest son were executed for treason on consecutive days in 1645 for refusing Charles I entry to Hull. The current house at Scorborough remains part of the Hotham estates and is surrounded by the remains of the moat and fishponds of the original manor house.

South Ella Hall, Anlaby

The Hull banker Robert Copeland Pease (later baronet) built South Ella after he bought the land in 1808 from R. C. Broadley. In 1821 it was sold to the Hull solicitor John Broadley, who died in 1833. Broadley's trustees sold the house in 1838 to John Beadle, who lived there until his death in 1869. At its peak the estate extended to over 100 acres, reduced by gradual sales from the 1920s onwards for housing. South Ella Hall, much extended during the nineteenth century, was demolished in 1959.

Spaldington Hall, Spaldington

A seat of the Vescis, FitzPeters and de la Hayes before it passed to the Vavasours, Spaldington Hall was rebuilt in Tudor times. The hall was demolished in 1838 and (Old) Hall Farm built on the site. Spaldington Hall was said to be haunted by a shapeshifting ghost known as Robin Redcap, supposedly a family jester who broke his neck when thrown down the stairs by his master.

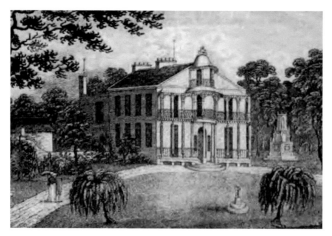

Summergangs Hall.

Summergangs Hall, Hull

Summergangs House was a delightful villa built in 1785 and modernised in around 1800 by J. K. Pickard, whose father had made a fortune introducing the white lead trade into Great Britain. Elaborate cast-iron balconies and a semi-circular porch were added at this time. J. K. Pickard's son served as an officer in the Horse Guards at Waterloo. A portrait of him in Hull's Ferens Art Gallery shows him sitting under the statue of George III placed by his father in the grounds of Summergangs Hall. The hall was bought by John Broadley in 1814 and in 1823, became a private asylum. The Jalland brothers acquired Summergangs in 1838, demolished it and replaced it with a new Elizabethan-style mansion called Holderness House designed by James Clephan.

Sunderlandwick Hall, Driffield

A neo-Georgian house of the early 1960s by Francis Johnson for Sir Thomas Ferens replaced an eighteenth-century house with Victorian additions that was destroyed by fire on VJ Day 1945. During the Second World War Sunderlandwick was occupied by the RAF. Previous owners included the Horner and Reynard families. Only the stable block survived the fire.

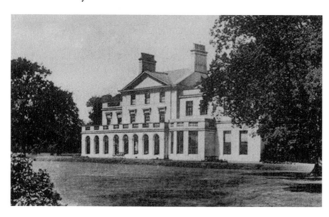

Sunderlandwick, the original house.

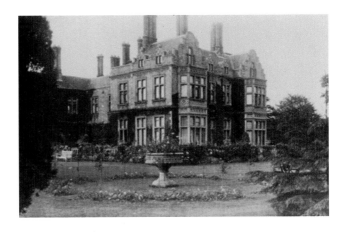

Swanland Manor.

Swanland Manor, Swanland
Swanland was a huge Jacobethan-style house built between 1848 and 1851 for Samuel Watson. A number of fittings are said to have come from a recently demolished house belonging to the Duke of Sutherland. It was bought by the industrialist James (later Sir James) Reckett in 1884. Reckett added a billiard room, extended the gardens and built a model farm. Swanland was inherited by Sir James' son Phillip, who lived in it until 1932. The house was demolished in 1935.

Tickton Hall, Tickton
The Tickton estate was formerly the property of the Telford family. The Elizabethan-style house built in 1846–47 for Edward Smith on the site of an earlier house was largely demolished in the 1960s. The surviving service wing and outbuildings were converted into the present house.

Tilworth Grange, Sutton-on-Hull
Built in 1810–20 for Hull merchant Hugh Casson in 1892, Tilworth Grange was the residence of James Allen Jackson. Tilworth Grange became a hospital for female psychiatric patients in 1921, but following its closure the Grange was demolished around 2000 and the land built over.

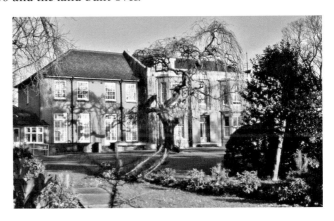

Tilworth Grange.

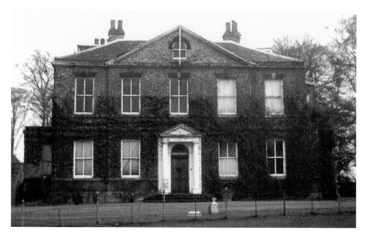

Tranby Lodge.

Tranby Lodge, Hessle

Tranby Lodge was built around 1810 by Hull merchant Samuel Cooper. Cooper sold the house to his fellow merchant Christopher Ringrose in 1841. It was later the home of Lt-Col Gerard Smith. The Lodge remained in good condition as a home until the 1960s. Following the death of its owner, a property company bought the house with the intention of redeveloping the site. Planning permission was refused and the house was allowed to deteriorate despite offers to purchase the house for restoration as a family home. After a long period of increasing dereliction, Tranby Lodge was demolished in 1985.

Tranby Park, Hessle

Tranby Park was built around 1810 by Hull grocer and merchant William Todd, and remained in the Todd family until the 1890s. The architect was Joseph Ireland. Tranby Park was demolished in 1950.

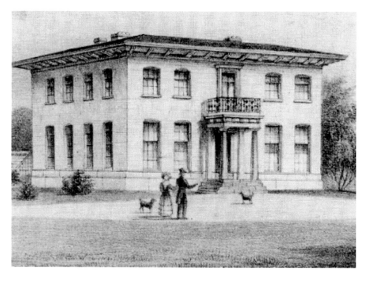

Tranby Park.

Warter Priory, Pocklington

The Warter estate was acquired by the family of the Lords Muncaster in 1697 as a result of the marriage of William Pennington to Isabel Stapleton, heiress of John Stapleton of Warter. The Penningtons' principal home was (and remains) Muncaster Castle in Cumbria. The house was originally Warter Hall, becoming Warter Priory in the 1830s after an Augustinian priory, the site of which was close by.

The final mansion began as the late seventeenth- or early eighteenth-century two-storey five-bay house with two bay wings illustrated by Samuel Buck. This was extended in around 1760, in 1830 and in 1872 was refronted in French Renaissance style by J. B. and W. Atkinson for the 5th and last Lord Muncaster when corner towers were added to the original front.

Warter was sold in 1878 to Charles Wilson, a Hull shipping magnate who was created Lord Nunburnholme in 1906. He commissioned a massive enlargement of the house by the Hull architects Smith and Broderick between 1885 and 1895. They added a clock tower with porte-cochere, a baronial hall with panelling by Elwell and Sons of Beverley and a marble staircase. The final house had more than 100 rooms with more than thirty bedrooms, but was rambling, shapeless and of little architectural distinction; the interiors, however, were sumptuous. The Nunburnholmes employed around twenty-two indoor and forty outdoor servants. Lord Nunburnholme died in 1907 but his widow lived on in the house for a further twenty years.

In 1929 the house was bought by the Honourable George Vestey, second son of the 1st Lord Vestey, who died in 1968 having maintained the house and gardens in Victorian splendour. In 1968 the house and 14,500-acre estate were sold to the Marquess of Normanby and the Guinness Family Trust. The Marquess bought Warter as a shooting lodge, his family seat being Mulgrave Castle. Lord Mulgrave converted a farmhouse on the estate into a residence to the designs of Francis Johnson. Warter Priory was demolished in 1972 and farm buildings were built on the site. Rubble from the mansion was used to fill in the lake. Malcolm

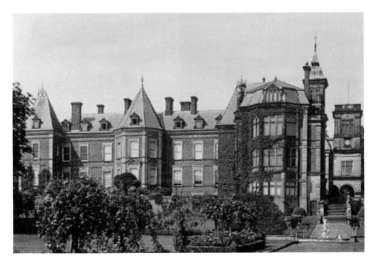

Warter Priory.

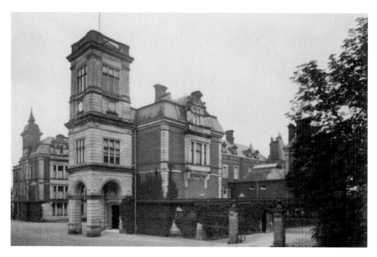

Warter Priory.

Healey bought the 12,000-acre estate for £48 million in 1998. In 2018 plans were announced for the building of a new classical house. The church of St James nearby contains a fine series of monuments to Penningtons and Wilsons.

Wawne Hall, Wawne

The Windham family held the manor of Wawne from the seventeenth century and built themselves Wawne (Waghen) Hall in the late nineteenth century. The core of the building was a farmhouse, rather shapelessly extended into a long, low building in a vaguely Elizabethan style. The last of the family to live at Waghen was Major Ashe Windham, who left in the 1920s. The house was in poor condition by the mid-1930s and was demolished in the 1950s after it had been requisitioned during the Second World War.

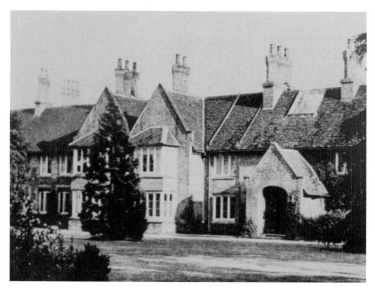

Wawne Hall.

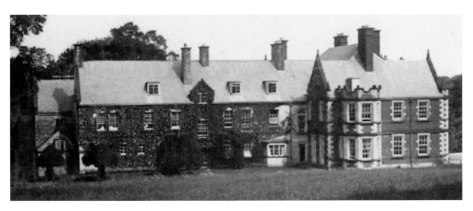

Welham Hall.

Welham Hall, Welham

There have been two houses on the site of Welham Hall, both now gone. The first, the seat of the Bower family, was burnt down in 1884. The second was built in the 1890s by Colonel Legard. Following the sale of the estate, the second house was demolished in 1957.

Welton House, Welton

Welton House, demolished in 1952, was an enormous mansion that was once the heart of the Broadley family's 15,000-acre estate. A house on the site is first recorded in 1748 when Hull merchant James Shaw is believed to have built a home there. On Shaw's death, the house passed to Thomas Williamson, another Hull merchant with interests in the Swedish iron trade. Williamson demolished the old house and rebuilt it on a grander scale as well as landscaping the grounds. Capability Brown and Thomas White provided landscape designs in 1769. The nearby road from Welton to Melton was moved, with the old road becoming the drive to the house, and the East Lodge (demolished around 1965) was built.

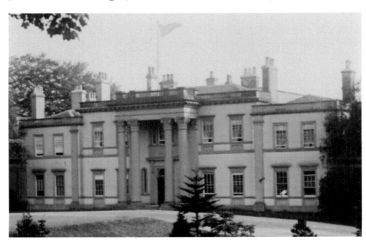

The front entrance of Welton House.

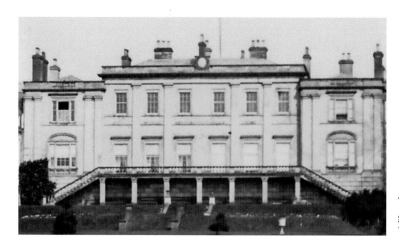

The front
garden of
Welton House.

Williamson left the house and estate to his son-in-law, Robert Raikes, who pulled down the second house and rebuilt it. Raikes also built himself a fine mausoleum and died in 1837. After the death of his widow Anne (née Williamson) in 1848, the estate was sold to Henry Broadley, MP for the East Riding from 1837 to 1851. Broadley was also the first chairman of the Hull & Selby Railway.

On Broadley's death in 1851, the property passed to his fifth sister, who in turn left it to her nephew William Henry Harrison, who became Harrison-Broadley in 1865. Harrison-Broadley was unmarried and upon his death, in 1896, the estate passed to his nephew Henry Broadley Harrison-Broadley, who died in 1914. His widow lived in the house until 1926. Welton began to decline after the family left and was requisitioned during the Second World War. Further decline after the war led to its demolition in 1952. The West Lodge and the mausoleum survive.

During its relatively short life, Welton grew and grew. The core of the house in its final form was probably the house built by Raikes, which had a huge portico on its north side. Henry Broadley made massive additions and later Broadleys extended it still further, also adding a huge conservatory. The result was vast and completely unsuitable to domestic occupation. Its demolition was perhaps inevitable. The grounds of Welton have now been largely built over, but the street Temple Walk marks the location of a former garden feature. The first recorded instance of an accidental fatal shooting in England occurred at Welton in 1519.

Wheel Hall, Riccall

Wheel Hall belonged to the bishops of Durham from the eleventh century until the nineteenth century, and they had a manor house there until the eighteenth century when the present farmhouse was built on its site. Between the late seventeenth and early nineteenth centuries Wheel Hall was often let to the Mastermans. The bishops of Durham retained the manor until 1836, when it was transferred to the new diocese of Ripon. In 1873 the property was sold to Lord Wenlock. Two arms of a former moat are visible. The gatehouse and watergate house of the bishop's manor were mentioned in 1662 and later, and may have survived until the building of the farm.

Winestead Hall (Red Hall), Winestead

Winestead was the seat of the Hildyards for almost five centuries. In 1417 the estate of Sir Robert Hilton of Winestead was inherited by his daughter Isobel, wife of Sir Robert Hildyard of Arnold and Long Riston. Martin Hildyard (d. 1545) demolished the original manor house and built a new mansion not far away after his only son, William, was drowned in the moat of the old one. At the end of the seventeenth century Henry Hildyard left England for Continental exile after the deposition of James II, selling the house and estate to his uncle, Sir Robert, who was created a baronet. The house was rebuilt around 1720 by the 2nd Baronet, although it was probably completed by his nephew and heir Sir Robert (3rd Baronet). Details suggest that Lord Burlington may have offered advice on the project. The new house was known as the Red Hall to distinguish it from the nearby White Hall, which belonged to the Maister family, prominent Hull merchants.

The house consisted of two blocks joined together only at ground-floor level. The main block was almost a cube and of three storeys with an ionic stone cornice and parapet. Each of the main sides had five bays with a central pedimented doorcase on the west and south fronts. The house was of brick with stone quoins.

The ground floor of the house's main block contained a drawing room, entrance hall, library and morning room, as well as accommodation for the butler. There were four bedrooms and a dressing room on the first floor and six bedrooms on the second. The servants' rooms were in the attached smaller two-storey block to the north.

All the rooms were panelled and painted pale green and white, and most were elaborately decorated. The entrance hall, used as a dining room, had busts of classical figures on plaster brackets. Over the fireplace was a plaster medallion of the builder of the house, the 2nd Baronet, surrounded by a frame surmounted by the family crest of a cock.

In 1814 and after ten generations, the Hildyard baronetcy became extinct on the death of the 10th Baronet, who bequeathed the estate to his niece Ann Whyte. On her marriage to Thomas Thoroton of Flintham in Nottinghamshire, Winestead

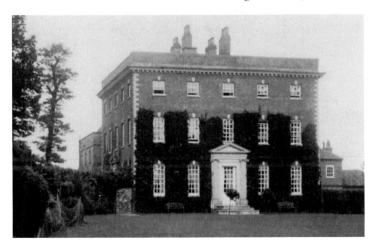

Winestead Hall.

became a secondary seat. After its sale in the 1890s, Winestead eventually passed to Hull Corporation, who demolished it in 1936 to make way for a hospital. All that remains are the stable block designed by John Carr and built 1762, and some subsidiary estate buildings. Some fittings from the hall were transferred to Flintham Hall, where the Hildyards are still seated.

Part of the estate sold by the Thoroton-Hildyards was bought by Colonel Rupert Alec-Smith, who converted the old rectory into the principal house to the designs of Francis Johnson. The new 'hall' incorporates some fittings from Red Hall and from other demolished buildings in Hull. It is now the home of Colonel Alec-Smith's daughter.

Andrew Marvell was born at Winestead Rectory and baptised in the nearby church in 1621. The church contains a series of Hildyard memorials.

Wressle Castle, Wressle

Thomas Percy was granted land at Wressle in 1364 and built the castle in the 1390s. Like the castles at Bolton and Lumley, it consisted of four ranges round a courtyard with corner towers and a gatehouse in the centre of one side. These three castles have been ascribed to a single architect. The castle returned to the Crown in 1537 after the Percys were compromised by the Pilgrimage of Grace. Wressle was held by Parliament during the English Civil War and partly demolished in 1646–50, leaving only the south range standing for use as a residence by the Percy family. In 1741 Henry Percy refurbished the building. In 1796, while tenanted by a local farmer, the castle was further damaged by a fire, which gutted the surviving wing. In 1957 the castle and farm were sold to the Falkingham family, who still own it.

The remains include the shell of the south wing, various fragments of other buildings and earthworks. Nothing survives of Wressle's spectacular formal gardens.

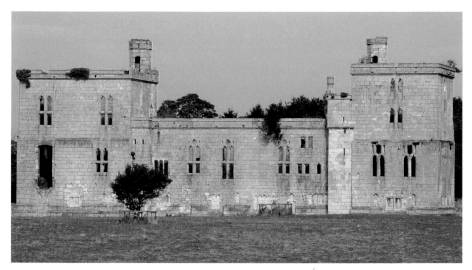

The south range of Wressle Castle.

Bibliography

A number of otherwise rare and prohibitively expensive books are now available as reprints of varying quality. In such cases, I have given the date and place of the original publication.

Books

Allison K. J., *Hull Gent Seeks Country Residence 1750–1850* (East Yorkshire Local History Society, 1981)

Armstrong, B. and W. Armstrong, *The Arts and Crafts Movement in the North East of England* (Wetherby: Oblong, 2013)

Armstrong, B. and W. Armstrong, *The Arts and Crafts Movement in Yorkshire: A Handbook* (Wetherby: Oblong, 2013)

Aslet, Clive, *The Last Country Houses* (Newhaven and London: Yale, 1982)

Burke's Peerage, Baronetage and Knightage, 107th edition (Burke's Peerage and Gentry LLC, Wilmington, Delaware 2003)

Cahill, Kevin, *Who Owns Britain?* (Edinburgh: Canongate, 2001)

Gliddon, Gerald, *The Aristocracy and the Great War* (Norwich: Gliddon Books, 2002)

Hatcher, Jane, *Richmondshire Architecture* (Richmond: CJ Hatcher, 1990)

Haward, Winifred, *The Secret Rooms of Yorkshire* (Clapham: Dalesman Publications, 1956)

Healey, Edward, *A Series of Picturesque Views of Castles and Country Houses in Yorkshire* (Bradford: Thomas Shields, 1885)

Hey, David, *A History of Yorkshire* (Lancaster: Carnegie Publishing, 2005)

Hey, David, *Buildings of Britain 1550–1750: Yorkshire* (Derbyshire: Moorland Publishing, 1981)

Kluz, Ed, *The Lost House Revisited* (London: Merrell, 2017)

Mitchell, W. R., *Haunted Yorkshire* (Skipton: Dalesman, 1990)

Neave, David and Edward Waterson, *Lost Houses of East Yorkshire* (Georgian Society for East Yorkshire, 1988)

Neave, David and Deborah Turnbull, *Landscaped Parks and Gardens of East Yorkshire* (Georgian Society for East Yorkshire, 1992)

Pevsner, Nikolaus and David Neave, *The Buildings of England: York and the East Riding* (Newhaven and London: Yale, 1995)

Pevsner, H., *Yorkshire: The North Riding (The Buildings of England)* (Newhaven and London: Yale University Press, 2002)

Pevsner's Architectural Glossary (Yale University Press, 2010)

Philo, Phil, *Kirkleatham* (Langbaurgh on Tees Museum Service. ND)

Robinson, John Martin, *Felling the Ancient Oaks: How England Lost its Great Country Estates* (Aurum Press, 2011)

Ryder, Peter F., *Medieval Buildings of Yorkshire* (Ashgrove Books, 1993)

Salter, Mike, *Castles and Tower Houses of Yorkshire* (Malvern: Folly Publications, 2001)

Stephenson, Paul and H. Doreen Gibbins in association with Remember Middlesbrough Society, *Marton and Nunthorpe* (2003)

Strong, Roy, *The Destruction of the Country House* (London: Thames and Hudson, 1974)

Ward, J. T., *East Yorkshire Landed Estates in the Nineteenth Century* (East Yorkshire Local History Society, 1967)

Waterson, Edward and Peter Meadows, *Lost Houses of York and the North Riding*, 2nd edition (Jill Raines, 1998)

Willis, Ronald, *Yorkshire's Historic Buildings* (London: Robert Hale, 1975)

Worsley, Giles, *England's Lost Houses from the Archives of Country Life* (London: Aurum Press, 2002)

Guidebooks
Holy Trinity, Little Ouseburn
St Mary's, Studley Royal

Newspapers, Journals and Periodicals
Dales Life
Daily Mail/Mail on Sunday
Daily Mirror
Daily Telegraph
Evening Chronicle
Harrogate Advertiser
Horse and Hound
Mail on Sunday
North East Life
Northern Echo
Sunday Telegraph Magazine
Teesdale Mercury
Telegraph and Argus
The Times
York Evening Press
York Press
Yorkshire Evening Post
Yorkshire Life
Yorkshire Post
Yorkshire Ridings Magazine

Acknowledgements

Many of the illustrations are from my own collection; however I am hugely grateful to the following for their generosity in providing images.

I owe a particular debt of thanks to Matthew Beckett for the images of Brough House, Clervaux Castle, Drax Hall, Eastthorpe Hall, Hildenley Hall, Hutton Bonville Hall, Kilnwick Hall, Neswick Hall, Scriven Hall, Stanwick Park, Studley Royal, Welham Hall, Wiganthorpe Hall, Winestead Hall and Wood End.

Middlesbrough Council Archive Service kindly provided the following illustrations of Gunnergate Hall, Thornton Hall, Tollesby Hall and Upleatham Hall.

The photograph of Park House is from the Walter Brelstaff Archive and reproduced with grateful thanks.

I would like to thank Stuart Pacitto of Middlesbrough City Council and Stewart Ramsdale, Conservation Officer of Redcar and Cleveland Council, for assistance with the illustrations.

The Northern Echo kindly allowed me to reproduce their photographs of the now lost Gatherley Castle, Halnaby Hall and Scruton Hall.

Redcar and Cleveland Council provided the illustrations of Hutton Hall and Kirkleatham Hall.

David Neave, joint author with Edward Waterson of *Lost Houses of East Yorkshire*, the pioneering book on the subject, most generously provided me with the otherwise almost impossible to find illustrations of Cottingham Hall, East Ella Anlaby, Kingtree House, Melton Hill House, the Mansion Anlaby and Tranby Lodge, and I am enormously grateful for his kindness. David also very kindly put me in touch with his fellow author Edward Waterson, who has been exceptionally helpful with this project in many ways as well as providing the illustration for Dringhouses Manor.

John Hoare very kindly allowed me to reproduce his rare photograph of Cottingham Grange. David Smith generously provided the illustration of High Paull House. Sandra Powlette of the British Library most kindly photographed and provided the images from Samuel and Nathanial Bucks' sketchbooks.

The photographs of Northfield House and Tilworth Grange are very kindly provided by Bernard Sharpe.

The illustration of Meadowfields, Whitby, was most kindly provided by John Moreels and the Photomemories Archive (www.photomemoriesarchive.co.uk). The image of Belle Vue, York, is used by kind permission of the Borthwick Institute, University of York.

The images of Stillington Hall are reproduced by kind permission of the Stillington Community Archive.

The photograph of Barden Tower is by Dr Neil Clifton, Middleton Quernhow Old Hall by Chris Heaton and Slingsby Castle by Martin Dawes, and are used under the Creative Commons licence with their kind permission.

Dr Julie-Anne Vickers, archivist at York Libraries and Archives, was most helpful in locating and providing the images of Holgate Lodge, North Lodge, Ousecliffe House and The Glen. Claire Weatherall, archivist at Hull University Archives, was similarly kind in locating and providing illustrations from the unrivalled collections amassed by David Neave and Edward Waterson while writing *Lost Houses of East Yorkshire* (Aston Hall, Bellefield, Camerton, Cottingham Grange, Cottingham Hall, Hildenthorpe House and Melton Hill House).

As far as I have been able to determine, the illustrations of Bishop Burton, Burstwick Hall, Easington Hall, Elmswell Old Hall, Fulford Field House, Hotham House, Huby Hall, Londesborough Hall, Paull Holme Manor, Risby Hall, South Ella Hall, Summergangs House and Wressle Castle are in the public domain. If this is not correct, I would be happy to make an amendment to future editions.